Ancient Egyptian Art and Architecture:
A Very Short Introduction

VERY SHORT INTRODUCTIONS are for anyone wanting a stimulating and accessible way in to a new subject. They are written by experts, and have been translated into more than 40 different languages.

The series began in 1995, and now covers a wide variety of topics in every discipline. The VSI library now contains over 350 volumes—a Very Short Introduction to everything from psychology and philosophy of science to American history and relativity—and continues to grow in every subject area.

Very Short Introductions available now:

Available soon:

For more information visit our website

www.oup.com/vsi/

Christina Riggs

ANCIENT EGYPTIAN ART AND ARCHITECTURE

A Very Short Introduction

OXFORD
UNIVERSITY PRESS

OXFORD
UNIVERSITY PRESS

Great Clarendon Street, Oxford, OX2 6DP,
United Kingdom

Oxford University Press is a department of the University of Oxford.
It furthers the University's objective of excellence in research, scholarship,
and education by publishing worldwide. Oxford is a registered trade mark of
Oxford University Press in the UK and in certain other countries

Published in the United States of America by Oxford University Press
198 Madison Avenue, New York, NY 10016, United States of America

British Library Cataloguing in Publication Data
Data available

Library of Congress Control Number: 2014940247

ISBN 978-0-19-968278-2

Printed in Great Britain by
Ashford Colour Press Ltd, Gosport, Hampshire

Links to third party websites are provided by Oxford in good faith and
for information only. Oxford disclaims any responsibility for the materials
contained in any third party website referenced in this work.

For Casey,
who once called an odd duck a rara avis

Contents

Acknowledgements

My sincerest thanks to Gay Robins and Tom Hardwick for their insightful comments on the manuscript—and for so many enjoyable and illuminating conversations about Egyptian art and architecture over the years. I am also grateful to Barbara Mendoza for discussing her research on bronze statues with me.

At Oxford University Press Andrea Keegan and Emma Ma have seen the work through from commissioning to publication with encouragement, patience, and professional grace, while picture researcher Deborah Protheroe deserves special mention for bringing the text to life with the image selection.

Like most people who venture into academic life, I have been privileged to study with a number of remarkable teachers, each of whom has touched this book in different ways: John Baines, who has been an inspiration in person and through his body of work; Helen Whitehouse, who taught me how to look closely at objects and materials; the late C. A. Keller, who was as generous with her knowledge as she was self-effacing in its presentation; and Casey Jenkins, whose English classes were lessons in life (and writing— same thing) as well as the start of a life-long friendship.

List of illustrations

Chapter 1
Four little words

Ancient Egyptian art and architecture: what does that phrase bring to mind? Depending on your interests and education, what movies or TV programmes you've seen, and what countries and museums you've visited, your answer might consist of pithy, evocative nouns like pyramids, mummies, and tombs, or famous names like Tutankhamun, Cleopatra, and Nefertiti. Perhaps you've visited the British Museum and bought a postcard of the Rosetta Stone—a consistent best-seller in the gift shop. Perhaps you've seen 19th century cemeteries where slant-sided, pyramid-topped pillars punctuate the landscape, smaller siblings of the ancient obelisks that grace New York's Central Park, London's Embankment, the Place de la Concorde in Paris, and a dozen piazzas in Rome. Or perhaps you've relaxed on a Nile cruise, sweated up the Grand Gallery of the Great Pyramid, or seen Egyptian-inspired buildings closer to home, like the Luxor Hotel in Las Vegas, or the Carreras Cigarette ('Black Cat') Factory in London, where 2.6-metre-high cat statues flank the entrance, based on ancient examples.

The art and architecture of ancient Egypt have been part of European consciousness for centuries, and especially the past two centuries of the modern era. Egyptian art is a highlight of the world's leading museums, including the Louvre, the Metropolitan Museum of Art, and the Vatican, while the temples, tombs, and pyramids of Egypt remain an enduring attraction, despite a

1

decline in tourist numbers following the 2011 revolution. From colossal stone statues to tomb paintings in fresh-as-new colours, Egyptian art creates an impression of grandeur and majesty on the one hand, and of immediacy and elegance on the other. Egyptian architecture also seems to be summed up by a handful of characteristics, such as the monumental gateways with sturdy columns, sloping side walls, and a flared cornice that were so readily incorporated in 19th century Egyptian-inspired ('Egyptian Revival') buildings. Some objects and buildings from ancient Egypt have become iconic. The Great Pyramid, the gold funerary mask of Tutankhamun, the painted bust of Nefertiti, and the Rosetta Stone are four examples of works which, like the *Mona Lisa*, have been reproduced so often, and in so many media, that their original contexts, materials, and meanings are almost forgotten.

Given that the visual arts of ancient Egypt are such a long-established and well-recognized form of cultural production, you might think they have been the subject of considerable research, and that many Egyptologists, art historians, and archaeologists continue to devote themselves to the study of Egyptian art and architecture. Not quite, which is one reason this book exists. For all the quantity, and quality, of Egyptian art and architecture that survives today, not to mention the influence it has had in modern times, the subject has been sidelined in terms of how universities conduct teaching and research. There are many reasons for this, which we'll consider later in this chapter, but for now, it's worth pointing out that surveys and textbooks of art history—Ernst Gombrich's *The Story of Art* or Honour and Fleming's *A World History of Art*, for instance—devote only a handful of pages to ancient Egypt before moving on to their meat and potatoes, the art of ancient Greece and Rome closely followed by European art from the Middle Ages onwards. If art history treats ancient Egypt as a tiny taster, do archaeology and Egyptology offer a more substantial alternative? Yes and no. There are many books written about Egyptian art and architecture, often in the form of

chronological surveys that give readers an overview of some 3,000 years of art. Museums produce guidebooks or online features about works in their collections, and they may publish exhibition catalogues focusing on a specific time period, site, or theme. But with a few exceptions, such scholarship rarely tackles the visual and material world of ancient Egypt in depth or grapples with the ideas, methods, and theories that characterize the most interesting work being carried out in other fields today, including classical archaeology, art history, anthropology, and museum studies. A typical Egyptology degree involves language training, history, religion, and knowledge of archaeological sites. Explicit coverage of art and architecture features less often, even in universities that have an Egyptian collection in an affiliated museum.

At this point, the four key words that make up the title of this book—'ancient', 'Egyptian', 'art', and 'architecture'—may be starting to seem more complicated than they first appeared. And so they should, for each of those words is problematic in its own way. Thinking about the problems each word raises can help us think in more detail about the visual arts of ancient Egypt and about some of the issues touched on above: how Egyptian art and architecture are studied and discussed, why and how they have influenced the modern world, and whether iconic examples of Egyptian artworks and building types are in any way representative of cultural norms and lived experience in the ancient past. The rest of this chapter explores each word in turn, and in doing so introduces the themes and ideas that underpin this book.

Ancient

When is 'ancient' Egypt? This book considers objects from a period of some 3,500 years, but with their later lives in mind as well. Most Egyptologists think about ancient Egypt as a culture that exhibited a high degree of political, linguistic, and social

coherence for around this span of time. But the start and end dates vary. Did this culture begin with the first known rulers, kings like Narmer ('Fierce Catfish') and Scorpion around 3100 BC? Or should the start date be hundreds of years earlier, when there is archaeological evidence for sophisticated craft production such as textiles and pottery? The question of where to end ancient Egypt is even thornier. Some writers suggest the invasion by Alexander the Great in 332 BC, which ended the rule of indigenous Egyptian kings; others say the death in 30 BC of Cleopatra VII, the last of the Macedonian Greek rulers; and still others include the ensuing period when Egypt was part of the Roman Empire, but see things fizzling out around AD 300, when Christianity became the dominant religion and the Empire split in two.

The form in which we express these dates conveys something of the larger issues at stake here, with BC meaning 'before Christ' and AD 'anno Domini', 'the year of our Lord'. Such expressions of time assume a Christian perspective, and it is the change first to Christianity and then, from the mid-7th century, to Islam that demarcates cultural epochs in Egypt. As a result, ancient Egyptian, classical, Christian, and Islamic objects are studied by different kinds of scholars and usually collected and displayed in different parts of a museum, or even different museums. The period before Alexander the Great is usually known as Dynastic or pharaonic Egypt, since an account written by the Egyptian priest Manetho around 300 BC grouped the kings, or pharaohs, of Egypt into thirty dynasties. Unlike the Jewish, Christian, and Islamic systems of counting years continuously from a set point, the Egyptian system started counting again with each new ruler, which made it essential to know the order in which kings reigned, and for how long.

Measuring and accounting for time was one of the first concerns scholars had in understanding the distant past. In the 17th century, long before the development of archaeological methods, an Irish archbishop named James Ussher used evidence from the

Bible and Roman historians to calculate key dates in ancient history, famously placing the creation of the world in 4004 BC. Only in the 19th century, when linguists were able to read hieroglyphic texts from Egypt, and cuneiform from Iraq, did it become possible to establish a more accurate and detailed chronology. Archaeologists also began to develop methods for interpreting stratigraphy (layers of evidence underground) and relating artefacts to each other in sequences of types or styles. This meant that prehistoric cultures—those without written records—could be incorporated into a chronology as well. In Egypt, these cultures were called Predynastic to distinguish them from the dynasties of named kings, although a Dynasty '0' of kings has been inserted as archaeologists find more evidence for an early form of statehood.

In the late fifth millennium BC, around the time Ussher thought the world had been created, prehistoric people in the Nile valley began to settle in areas suited to agricultural production, although many continued to travel seasonally with herds of animals. The river provided an easy route for trade and communication, allowing settlements to establish links with each other. A more complex society emerged, in which material goods like pottery, stone, basketry, and food stuffs enabled social cohesion as well as differentiation, for instance to determine status and hierarchy. By the end of this millennium, around 3200 BC, a site known as Coptos (Arabic *Qift*) was home to an enclosure, perhaps a temple, in which British archaeologist W. M. Flinders Petrie (1853–1942) found the remains of at least three colossal limestone statues (Figure 1). Each statue originally stood more than 4 m high and weighed around 2 tons; two of the statues are in the Ashmolean Museum, Oxford, while the third is in Cairo. The sole surviving head is battered, but has a round, moon-like face with traces of a beard. Egyptologists identify the subject of the statues as the deity Min because later in Egyptian history, Coptos was the centre of worship for this god, who was usually depicted grasping his erect penis much like the statues Petrie found. This identification seems

5

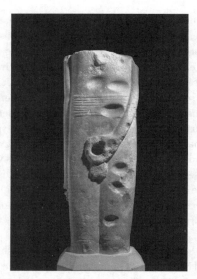

1. Statue of the god Min *c.*3300 BC. This limestone statue, identified as the god Min, once stood with several others in a Predynastic temple at Coptos

reasonable enough—but it does rely on projecting later evidence backwards in time and asserting seamless continuity where the reality was almost certainly as disjointed as the surviving statues themselves.

Ancient and other histories are written on the bodies of the statues, which have a distinctive appearance even in their fragmentary state. When they stood upright, their height in relation to a human must have made them quite visible and imposing. The existence of multiple statues suggests they were arranged in relation to each other, perhaps set around the enclosure at significant points. The statues depict a male, human body with long, slender legs and arms, carved without piercing the stone. There is little sculpted volume to convey the contours of

6

muscle and flesh, except for the flat, raised triangles that define each knee. Horizontal lines around the waist define a belted sash whose ends extend straight down the side of each statue's right leg, where carved symbols represent decorated poles or standards, animals, and shells from the Red Sea. Since Coptos lies at one end of a 200-kilometre (km) valley from the Nile to the Red Sea, these symbols may refer to a place or an event—an expedition?—but their precise meaning is unclear, and perhaps had different interpretations in antiquity as well.

For viewers today, the two most striking aspects of the statues' appearance are the hole where a separate piece of stone was inserted for the penis (now emphasized by the statues' fragmentary state), and the oval grooves hollowed out of the surface in several places. Both of these features remind us that the experiences of time depth and cultural change are more involved than any neat historical divisions can convey. The separate penis, for instance, was a practical solution to the problem of how to make this body part stick out from the statue, since stone would crack under its own weight if carved in one piece. But using a separate element also meant this body part could be changed over time, for instance to renew the statues. At the Ashmolean Museum, a stumpy shaft from the same excavation, carved of different limestone, fits into one of the statues—but is it the same age or is it a later replacement, and for how long were the statues still standing at Coptos?

This brings us to the second feature, the oval depressions where stone has been ground out, probably in the belief that it had healing properties. On the statue in Figure 1, the grooves are concentrated on one side, suggesting that the other was buried and inaccessible when the grinding took place. It is difficult to say when the grinding occurred—a hundred years after the statues were made, or a thousand, or more? In the 19th century, Western visitors to Egypt observed that local people from the labouring or farming class (*fellahin*, in Arabic) would grind stone from temple

7

walls, producing grooves and depressions that are now high up the wall, where village street levels lay before archaeological clearance. In the parlance of the time, Europeans saw such evidence as 'folklore' exemplifying a belief in magic that survived from pre-Islamic times—and implying that modern Egyptians were 'primitive', even that Islam was only a veneer over ancient, pagan practices. Characterizing non-Western cultures as unchanging and thus less advanced than the West is an idea that persists among some writers and tourists. Many people interested in ancient Egypt know little about its later history, a problem reinforced by the way scholars and museums separate art by periods or cultures without considering how these coincided or interacted. In order to think about time, in other words, we have to think about place as well.

Egyptian

A viewer or museum visitor unaware of where the Coptos statues had been found might not guess that they were from Egypt, because they do not conform to common notions of what Egyptian art looks like—the 'walk like an Egyptian' poses of two-dimensional images, or the placid faces and well-defined figures of more familiar sculpture, like the statue in Figure 2. This lifesize figure of a man, now headless, stands confidently on a rectangular plinth, left leg forward and arms straight down, each hand in a loose fist. It is carved from a single piece of hard, dark granite. The muscles are shapely and powerful, and the shoulders and hips square with the front edge of the plinth. A strong ridge defines the shin bones and leads the eye to the well-defined knees, while a short, wraparound skirt—the only clothing—draws attention to the way the garment pulls across the thighs. Apart from the rough surface where the sandals, necklace of rams' heads, and bracelets were gilded, the stone has been polished to a rich, dark sheen. On top of the plinth, and on the king's waistband, hieroglyphs written in oval shapes (cartouches) signal that the statue represents a king, since only royal names were written with these

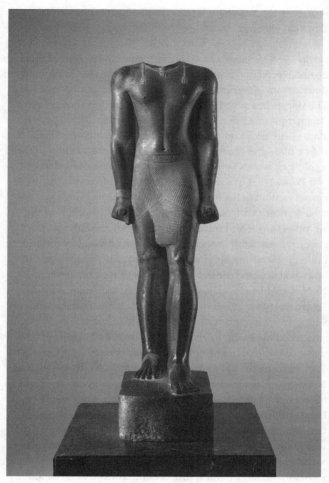

2. Statue of king Tanwetamani *c.*650 BC. Discovered in a pit at Jebel Barkal in Sudan, this granite statue of king Tanwetamani had gilded sandals, bracelets, and a necklace decorated with rams' heads. Egyptian, Late Period, 25th Dynasty (*c.* 715–656 BC), Statue of Pharaoh Tanwetamani, 664–653 BCE, black granite, height 79½ inches (202 cm)

protective rings. So here we have it: an Egyptian statue of an Egyptian pharaoh.

Or do we? This piece was found with nine similar statues broken up and buried in pits at Jebel Barkal, a site that lies around 20 km downstream of the fourth cataract of the Nile, in modern Sudan. The statues lined the route to a temple of the ram-headed god Amun, ransacked by Egyptian troops in 593 BC. The king our statue depicts did rule Egypt for a time, like his father Shabaka before him—but the family were first and foremost kings of Kush, a gold-rich region that stretched from the confluence of the Blue and White Niles to a shifting border zone with Egypt. During a power vacuum in the 8th century BC, the kings of Kush extended their territory north as far as Thebes; finally, they claimed the Egyptian throne and ruled both countries for the best part of a century, as the 25th Dynasty. Centuries of economic trade and military skirmishes between Egypt and Kush—many Egyptian kings had asserted control over the border region known as Nubia ('gold land')—meant that the Kushite rulers had made Egyptian-style art their own, probably because of its associations with prestige and power, not to mention the availability of artists who could work with its recognizable forms and preferred materials. The statue we've been looking at represents king Tanwetamani, the last joint ruler of Egypt and Kush (664–653 BC). Forced to retreat by the Assyrian army, Tanwetamani returned to his ancestral homeland, where all the Kushite kings were buried. He and his successors continued to build pyramids, decorate temples, and create statues and jewellery in a visual idiom that was distinctly theirs, but at the same time indebted to Egyptian art and architecture. This may be an Egyptian statue of an Egyptian pharaoh, but it is just as fair to consider it a Sudanese statue of a Sudanese king.

The statue of Tanwetamani makes the point that although 'Egyptian', in an ancient context, refers to a place and the people who lived there, it also refers to features or characteristics

connected to Egypt in some way, such as an artistic form, a style of dress, or language and religion. Egypt played a prominent political, economic, and military role in north Africa, the eastern Mediterranean, and the ancient Near East for several centuries, which meant that Egyptian objects were desirable commodities—whether or not they had been made in Egypt. In the 9th and 8th centuries BC, for instance, craftsmen from Phoenicia on the Levantine coast carved ivory panels, used as inlays, in imitation of Egyptian styles. The fact that hundreds of these carvings were excavated in an Assyrian palace at Nimrud, northern Iraq, shows that they had widespread appeal, their status as luxury goods due in part to their Egyptian 'look'. Egypt's far-reaching influence in the ancient world meant that it exported works of art, too. On the Greek island of Samos, bronze statuettes made in Egypt around the time of Kushite rule were dedicated to the goddess Hera, and Greek traders visiting Egypt might have studied the techniques of bronze casting and stone carving used by Egyptian artists. When Egypt was part of the Roman Empire, whole obelisks and statues were shipped to Rome, but sculptors in Italy also made new, Egyptian-inspired works to adorn imperial villas (see Figure 20 in Chapter 6) and temples of the Egyptian goddess Isis. Some scholars prefer to call these works, and the Phoenician ivories, 'Egyptianizing' rather than Egyptian, but it was their Egyptian look that mattered at the time, not their geographic origin.

Books about ancient Egypt often state that geographic features provided it with natural boundaries: in the south, at Aswan, the first of several cataracts made the Nile difficult to navigate; to the east and west lay mountain ranges and desert; and to the north lay the Mediterranean. But as the examples of Kush, Phoenicia, and Samos demonstrate, these boundaries were permeable, and people moved through them in every direction. Where and what was 'Egypt' in antiquity, then, and how did its people describe themselves and their land? In the ancient Egyptian language, the most common name for Egypt was 'The two lands', meaning the north and south, the Delta and the Nile valley. These two regions

were considered in danger of splitting apart, and one of the king's duties was to unite them. The modern word 'Egypt' comes from Latin (*Aegyptus*) and Greek (*Aegyptios*), and probably derives from the Egyptian and Coptic word *Hikuptah*, referring to a temple of the god Ptah at the key city of Memphis which, like Cairo, held a strategic position where the Delta and the Nile valley meet. In Arabic, Egypt is *Misr* from Mizraim, identical to its ancient Hebrew name. At several points in ancient history, the modern boundaries of the nation-state of Egypt bore some resemblance to pharaonic territories—but the idea of a nation-state, to which people belong by territory, is a very recent one, developed in 18th and 19th century Europe. Instead, being Egyptian was probably defined by customs, language, and parentage or place of birth. Nonetheless, people who moved to Egypt could adopt names and habits to 'become' Egyptian, and in regions under Egyptian dominance, individuals who had never set foot in Egypt could be familiar with its language, religion, and art.

Although the Delta was home to some of the most populous towns and important religious centres, its sites are not as well-preserved or impressive as those in the Nile valley. This means that our idea of what is 'Egyptian' is skewed even within Egypt itself. Repeated floods, shifts in the Nile's course, and the fact that people tend to keep living in a given place if they can, building and rebuilding on top of it over time, all mean that few ancient towns and villages have survived, whereas cemeteries on the desert fringes, and stone temples and monuments more resistant to water or set far back from the riverbanks, have endured for centuries. The best known of these lie between Aswan in the south and Luxor (ancient Thebes), 200 km downstream. This has had a tremendous impact on how we think about art and architecture in ancient Egypt, and scholars face the challenge of dealing with what exists while keeping in mind what else there might once have been.

Art

For such a little word, 'art' throws up a number of problems when people try to define what 'art' is or categorize certain objects as 'art' to the exclusion of others. The word itself derives from the Latin *ars*, which has a meaning similar to the ancient Greek *techne*. Both referred to a whole range of arts and crafts, anything from baking and pottery to sculpting and painting, all tasks that required skilled manual work. The ancient Egyptian language has no near equivalent, but it had no word for religion either, and no one would argue that Egyptians were lacking that. In Chapter 3 we'll see that the Egyptians did have a rich vocabulary for describing what they valued in objects and materials and how they thought about the people who made them.

In medieval and early modern Europe, words for 'artist' and 'artisan' were essentially interchangeable until the 18th century, when Enlightenment thinkers started to consider some forms of cultural expression superior to others. Painting, sculpture, and architecture, together with certain kinds of music, theatre, and literature, became known as the fine arts, or *beaux arts* in French. For the visual arts, this meant that certain art forms, including textiles, ceramics, and jewellery, now held lesser status as decorative arts or, even lower down the ranks, examples of craft. The differences lay partly in the materials and skills used, but also in perceptions of refinement, quality, the artist's originality, and whether the object had a practical function. Each of these supposed differences is open to dispute, though: Botticelli's *Venus and Mars* now has pride of place in the National Gallery in London, but the artist painted it for a piece of furniture.

Looking at the mask that was placed over the head of Tutankhamun's wrapped, mummified body (Figure 3), most people would be content to call this a work of art—but it also flouts conventional understandings of fine art. For a start, the mask was a very functional object, and a magical one at that. The

13

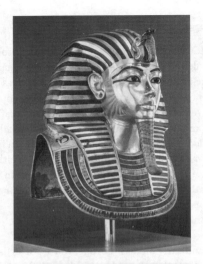

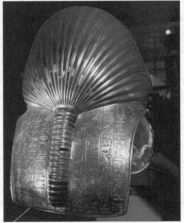

3. Funerary mask of king Tutankhamun, front and back views *c.*1323 BC.
The famous mask of king Tutankhamun is less familiar when seen
from the back, where verses from the *Book of the Dead* help protect
the mummy's face and head

hieroglyphic text incised on the back is one of the incantations from the *Book of the Dead*, ensuring that the dead king has a mask, called his 'secret face', for his divine existence in the afterlife. The materials and techniques employed for the mask also lie outside the Eurocentric 'fine art' scheme. Made of solid, beaten gold, its effect relies as much on the skill of the metalwork—notice the fine outline of the lips—as the lapis, carnelian, and solid glass inlays that make up the king's eyes, brows, and beard; the cobra and vulture heads on his brow; the bead collar across his chest; and the blue bands of his *nemes* headdress, a kind of scarf that symbolized the king's solar power and gleaming presence. In ancient Egypt all these materials and the skills to work them were highly valued and rich in symbolism; unlike Botticelli, though, we have no idea of the artists' names.

When scholars write about art in ancient Egypt, they sometimes convey uncertainty about whether it really is art, or how it compares to other ancient art, especially from classical Greece. Not only does this reflect the insupportable distinction between 'fine' art and other art forms, but also it reveals the influence of earlier ideas that privileged Greek art. When Johann Joachim Winckelmann (1717–68) published his pioneering history of ancient art in 1764, he described Egyptian, Etruscan, Greek, and Roman art based on what he had seen in Rome, characterizing each culture in terms of its artistic originality, how closely the art mimicked the natural world, and to what extent each society had flourished and, as he saw it, declined. Classical Greek art (or what Winckelmann thought was classical Greek art) won on all counts. Similarly, the philosopher Georg Hegel (1770–1831) ranked Greek art and architecture over Egyptian in *The Phenomenology of Spirit* (1807), his study of how human consciousness developed. Works like the Sphinx, Hegel argued, showed that the ancient Egyptian spirit had been stunted in heavy sculptures that represented impossible, half-human beasts. This didn't prevent European museums and private collectors from acquiring, and even admiring, Egyptian art, but, schooled in such ideas, they were less

likely to discuss its aesthetics and more likely to take an interest in any inscriptions it bore, especially if these helped identify historical personalities or aspects of ancient life.

But thinking about the material and visual properties—that is, the aesthetics—of Egyptian art does not exclude considerations of historical context, much less any inscriptions. Far from it, because these are part of the interpretation of art and the essential role it plays in society. In Egyptology today, pejorative associations attached to art and aesthetics stem from outdated ideas about art history, in particular its early and mid-20th century preoccupation with formal and stylistic analysis. From the 1960s onwards, art historians rejected such formalism, but some Egyptologists who identified themselves as art specialists continued to pursue formalist studies, with interesting but inevitably limited results. Compounded by a professional divide between Egyptologists who work in museums and those who work in universities, misapprehensions about how to study Egyptian art have left the subject in limbo. However, works of art and everyday objects are the means through which all scholars access ancient Egyptian culture—inscriptions, after all, were written on physical objects like papyri, statues, and tomb walls. Visual acuity is an essential skill to develop in order to understand an object's material qualities, its facture (means of making), and its age and authenticity, so that we can then consider how and what an object meant in its ancient contexts.

Architecture

'Architecture' is another word that betrays a Eurocentric bias in the way it is often used. The Enlightenment idea of the fine arts included architecture as an art form of its own, since the design and construction of buildings required unique aesthetic as well as technical abilities. But do all buildings count as architecture, or only those which meet certain standards of quality or importance—and who decides what those standards are? As with

art, a more open-ended and culturally inclusive definition of architecture is necessary when we think about buildings and spaces in ancient Egypt. For most people in antiquity the buildings in which they lived and worked affected their lives as much, or more, than the stone temples that astound viewers today. Domestic, agricultural, and urban structures in ancient Egypt were made of mud-brick or mud-plastered reeds, rarely preserved on archaeological sites. Culturally significant structures might be impermanent, too: the shelter where new kings were installed, or corpses prepared for burial, was little more than a tent.

With their impressive size, engineering feats, and sheer durability, temples and pyramids have defined ancient Egyptian architecture for centuries and influenced buildings like the 'Black Cat' Factory or Luxor Hotel mentioned at the start of this chapter. In the 19th and early 20th centuries, the Egyptian Revival incorporated distinctive Egyptian forms—temple gateways, papyrus-stem columns, and tapered obelisks—into all manner of buildings, though most often in relation to cemeteries and memorials, theatres, prisons, and industry. Permanence, peppered with exoticism, motivated these modern choices.

Permanence also motivated some of the choices made in ancient Egyptian architecture, but in a way that honoured ephemeral materials and the natural world. For instance, the columns used in temples, tombs, and palaces were carved in the shape of tent poles, reed bundles, or papyrus plants rising out of the Nile marshes, while column capitals resembled water-lily or papyrus flowers, the latter grouped into umbels. Stone gateways likewise took their form from reed structures, with bound bundles creating a rounded ridge around the doorway, called a torus moulding, and floppy fronds curving over the lintel in a flared cavetto cornice (see Figure 6 in Chapter 2).

Whether in stone, mud-brick, or reeds, architecture shaped living spaces and also offered a setting for other art forms. Plastered house and temple walls were painted, while stone walls in tombs

and temples were carved with images designed to fill every surface, making it impossible to extricate 'art' from 'architecture'. Tent-like structures staged important ceremonies, while grand temples were the context for sphinx-lined avenues, colossal statues, and thousands of smaller statues and objects donated as commemorations and offerings. Depending on the period and region, the tombs of the well-to-do were built above ground or cut into bedrock, but in either case, their equipment included statues, altars, and coffins, to name just three examples. One question this raises for ancient Egypt is whether architecture helped conceal certain works of art from public view, to heighten the power of the objects and their owners.

In their broadest senses, both art and architecture are useful categories for discussing objects, buildings, even bodies and performances that have been crafted with care and intent, and that often carry important cultural meanings. Although the ideas of art and architecture developed in the Enlightenment relied on assumptions about 'progress', and assumed that European values were universal, we can challenge this through the way we discuss, study, and present ancient Egypt. For this book, I consider art and architecture to comprise all those objects made in such a way that their form and materials contribute to, and often enhance, their representational power, social or symbolic significance, and aesthetic qualities, especially those perceived through the senses of vision and touch. This definition includes the more humble, everyday objects that archaeologists often refer to as material culture, but that find their way into museum collections and displays as well—the setting in which we are most likely to encounter Egyptian art today, and the subject of Chapter 2.

Chapter 2
Egypt on display

Prisons, cemeteries, and factories may have looked to ancient Egypt for architectural inspiration, but when it came to building museums, architects first turned to ancient Greece. The slender columns, triangular pediment, and stepped platform of a classical temple were preferred for the new 'temples' of art and culture that began to appear in the late 18th and early 19th centuries, such as the British Museum (founded 1753, main building erected 1820s–40s). Using architecture that spoke of a European past, whether that was a Greek temple or a Gothic cathedral, emphasized the important role museums were to play in the emerging modern world. As an institution, the museum shaped national and civic identity at a time when colonial expansion and industrial growth were changing social norms and, not coincidentally, filling those same museums with the fruit (and loot) of global trade.

Before around 1800, Egyptian antiquities were comparatively rare in Europe, apart from the obelisks imported to Rome by various ancient emperors. The 'cabinets of curiosities' formed by nobles, princes, and popes in the 16th and 17th centuries often included small 'Egyptian idols'—statuettes or magical figures—as well as the occasional mummified animal or human, in part or whole. But the difficulty of travelling to Egypt meant that few Europeans had been there, and then only as far as Alexandria or Cairo. All that

changed in the wake of the French Revolution, when Napoleon mounted a military and scientific expedition to the country. Claiming a model in Alexander the Great, Napoleon aimed to wrest control from the Mamluk *beys* who governed Egypt on behalf of the Ottoman Sultan—and to gain an advantage over Britain by creating a shorter sea route to India. He failed on both counts, and British forces, in collaboration with the Ottomans, defeated the French in 1801. Albanian-born military commander Muhammad Ali soon emerged to rule Egypt as viceroy on behalf of the Ottoman government, and looked to European powers like France and Britain to help modernize and industrialize Egypt. These twin developments—the maps, drawings, verbal accounts, and antiquities amassed by Napoleon's scientists, and Muhammed Ali's active courting of the West—opened the floodgates for the collecting and public display of ancient Egyptian art and increased Western familiarity with its architecture and monuments too.

One of the most famous objects in the British Museum today, the Rosetta Stone, owes its current home to the Napoleonic battle over Egypt. Part of a tall, granodiorite stela (a tablet that could be free-standing or set in a wall), the Rosetta Stone bears inscriptions in three languages—Greek, hieroglyphs, and demotic, a later form of Egyptian—that replicate a decree one of Cleopatra's forebears issued to the priests of an Egyptian temple in the Delta. The French forces who found it at Rosetta recognized that it could help decipher ancient Egyptian scripts, but had to relinquish it along with other antiquities to the British, who shipped everything back to join the collections of the British Museum. There, the museum authorities scarcely knew what to make of these dark stone slabs and statues, which were such a contrast to the flowing marble sculpture of Greece and Rome; at first, the Egyptian objects occupied a makeshift corner in a courtyard. The Rosetta Stone did prove to be the key that unlocked hieroglyphs, as the French scholar Jean-François Champollion proved in 1822. In the meantime, the Stone had

acquired a fourth language, which visitors have been able to see more clearly since it was cleaned and erected upright, instead of angled like a book, in 1999: white painted lines on either side declare, 'Captured in Egypt by the British Army in 1801' and 'Presented by King George III'.

The Rosetta Stone is in many ways an exceptional object, but as a museum object, it is very typical as well. Every object a museum collects and displays has its own story—how it came to be in a museum, what it has meant to different people at different times, and how a museum inevitably alters an object's original function, even its physical properties. This chapter looks at the lives that Egyptian antiquities have led in museum collections, not only to consider the history of collecting and interpreting these artefacts but also to suggest ways of looking at and asking questions about objects you might see when (or if) you visit a museum yourself. Museums are the places where most people are likely to encounter ancient Egyptian art in person, rather than on the internet, television, or in books, and as public venues they have played an important role in shaping how we think about ancient Egyptian culture.

Looking at Egyptian art

Small in size, large in number, and characteristically 'Egyptian' in appearance, the statuettes we now know as *shabti* or *ushabti* figures (the ancient spelling and meaning changed over time) were among the first Egyptian antiquities documented in early European collections. They were so recognizable and desirable, in fact, that forged *shabtis* were bought and sold as early as the 17th century, when they were must-have items for cabinets of curiosities, the precursors of public museums. Today, almost every collection of Egyptian art includes at least one *shabti*, and a large collection may have hundreds or even thousands of them, ranging from a few centimetres (cm) high to over 50 cm for some royal examples, although 10 to 25 cm is more usual.

One reason for this abundance is that *shabti* figures were produced in multiples for elite burials from around 1500 BC onwards, and in materials ranging from mud and stone to wood and, especially, a glazed, kiln-fired ceramic that Egyptologists call faience. An ideal set of *shabtis* had 365 'standard' figures, holding baskets and tools to perform manual labour, plus 36 'overseer' figures, to supervise the work of the *shabti* gangs—a total of 401 statuettes. This is why Egyptologists in the past, and some museums today, also refer to *shabtis* as 'servant statuettes' and describe their function as performing work for the deceased in the afterlife. But is there more to the *shabti* than this straightforward explanation might suggest?

The *shabti* in Figure 4 is one of 399 discovered in 1888 in a tomb at Hawara in the Faiyum region, dating to the 30th Dynasty (380–343 BC). The owner of the tomb was a man named Horudja, who was a priest of the goddess Neith, and the excavator of the tomb was none other than W. M. Flinders Petrie, whom we met as the discoverer of the Coptos statues in Chapter 1. Trained as a surveyor, Petrie introduced more systematic methods for conducting and recording archaeological fieldwork, and for collecting and preserving more of the objects he found, no matter how mundane they seemed. He also took advantage of the museum boom then taking place across Britain, continental Europe, and North America, as both regional and capital cities either founded new museums or expanded their existing collections. In industrial cities like Manchester, where some 58 of Horudja's *shabtis* found a home, Petrie garnered financial support from philanthropists and their local museums, in exchange for which each museum received a share of his finds. That is why the *shabtis* and other items from Horudja's tomb can now be found in museums from Cairo and Vienna to Amsterdam and New York. Until the 1920s, when Egypt began to introduce laws to restrict the export of its antiquities, foreign archaeologists like Petrie were allowed to keep many of the objects they found, leaving a selection

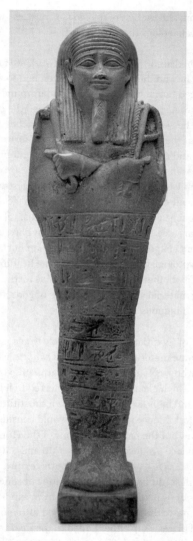

4. *Shabti*-figure of Horudja, *c.*350 BC. Around 400 figures like this one, called a *shabti*, were buried in the tomb of the priest Horudja

behind in Egypt; this system of division, or *partage*, was typical of colonial-era archaeology in the Middle East.

Petrie's published account of his 1888 fieldwork at Hawara describes how he and the Egyptian workmen had to wade through the water-logged burial chamber in the underground part of Horudja's tomb. A stone sarcophagus contained the coffin and mummy, and the *shabtis* were stacked in two niches at one end of the room. All of them had the 'standard' *shabti* form (Figure 4). Egyptologists and museum curators call this a 'mummiform' shape, because it shows the contours of a tightly shrouded body, which is how most mummies were wrapped. The straight-sided, blunt-ended head-covering appears on many images of gods and otherworldly beings, marking their divine status. Like the royal *nemes* headscarf (see Figure 3 in Chapter 1), it bares the ears, but it has a different shape and vertical, rather than horizontal, striations. Egyptologists refer to it as a 'divine headdress' or 'tripartite wig'; whether it was conceived of as textile, plaited hair, or some other material suited to the bodies of gods, the Egyptian image leaves ambiguous.

In any display of Egyptian art, you are likely to see many objects made in the same material as the Horudja *shabtis*, characterized by its green or blue colour: faience, or what the Egyptians called *tjehenet*, 'that which gleams'. They also referred to it by the words for turquoise and lapis lazuli, as if it were a substitute for these rare stones. Most faience is a shade we would consider blue or turquoise today, but the pale green colour of the Horudja *shabtis* is typical of faience produced between *c.*600 and 350 BC (26th to 30th Dynasties), as is its fine-grained, matte texture. Faience was a mixture of silica (derived from quartz stone or sand), alkaline soda (natron salt or plant ash), and lime (from sand or limestone), formed into a paste that was usually pressed into moulds. Copper-based glazes were either added to the mixture or applied to the surface of the object before it was fired in a kiln; broken

faience objects often show clear demarcation between the white or tan inner core and the layer of glazing on the surface. Any final carving of the material before firing required skill and careful timing, and no changes were possible once it left the kiln. On the back of Horudja's *shabti* is a circular paper label used to catalogue it in the museum in the early 20th century. More commonly, museums ink catalogue numbers onto an object, usually somewhere discreet—though you may be able to spot them on display. Here, the label was placed at the top of a flat, undecorated area connected to the plinth beneath the *shabti*'s feet. This is a feature Egyptologists call a 'back pillar', incorporated into all stone statues and many other figures, like *shabtis*. More than merely structural, the back pillar emphasizes the 'image-ness' of an image.

A *shabti* figure's equipment and the hieroglyphs written over its lower body are the reason museums sometimes describe these objects as 'servant statuettes', and they seem to offer a clue to their function. The depiction of hands on the otherwise concealed body was a convention in Egyptian art, allowing the artist to represent abstract ideas or characteristic attributes. Here, the *shabti* holds a hoe in its right hand, a pick in its left, and has a basket slung over its shoulder—tools for working in the fields. The inscription on Horudja's *shabti* is a magic spell from the collection we know as the *Book of the Dead*, where it is 'chapter' 6; other *shabtis* bear shorter versions of this spell or its variants, or only the name of the tomb owner, or else no inscription at all. Since hieroglyphs usually read from right to left, the spell starts on the back of Horudja's *shabti*, beginning with his name and a word normally translated as 'the illuminated one', meaning that Horudja existed in a state of grace after his death; the name of the god Osiris also precedes Horudja's name, and likewise points to his transfiguration in the afterlife. In the spell, Horudja addresses all his *shabtis* as if they were labourers being checked off ('counted') on a roll call for work. If Horudja, or his *shabtis*, are called up for work in the land of the dead, the *shabtis* are told to answer 'Here

I am!'. The spell is very specific about the work they will do: cultivating the fields, digging irrigation canals, and ferrying sand from one side of the river to the other.

Why was the afterlife associated with these particular tasks? They certainly represent hard physical labour, of the kind no one of Horudja's status would ever have had to perform. In this sense, *shabtis* give us a glimpse of Egyptian society, especially the multitude of unnamed people who did perform such work, and who cannot be found among the coffins, jewellery, and statues in museum galleries. But keep in mind that *shabtis* are magical figures, and the text is a magical formula: used the right way, such objects and incantations ('spells') might influence outcomes in an uncertain world. Thus the onerous work of digging canals or shifting sand—for instance, to provide the purified layer of ground on which temple foundations were laid—is a metaphor for overcoming spiritual or cosmological obstacles too.

Metaphor and magic can also help us understand why *shabtis* are identified so closely with their owner, by bearing his (sometimes her) name and resembling the shrouded mummy. They exemplify the powerful reach the Egyptian elite expected to have after death, and each figure manifests some of that potency and personhood, so that there isn't just one Horudja but a Horudja who exists beyond time and space, through his spirit, his descendants, and his tomb equipment. And in fact, *shabtis* weren't used just in burials but have also been found deposited as offerings at sacred sites—so even this most 'funerary' of objects had other roles and meanings.

For a museum, the challenge is how to use such a (deceptively) simple object in a way that does justice to its complexities. Depending on how it acquired its *shabtis*, a museum might own just a few donated by private collectors, or a few hundred received from archaeological digs. Museums then face any number of choices: they might display the *shabtis* in a section on burials, or

magic, or materials like faience; they might organize the *shabtis*
by size, date, or site; and they might isolate select *shabtis* to
emphasize their unique characteristics, or else play to their
multiplicity by displaying them en masse. Each of these choices
encourages museum visitors to see a *shabti* like Horudja's in a
slightly different way—and in a very different way from how
Horudja himself would have seen it.

The goddess who growled

When Egyptian artworks seized from the French army first
appeared in London, it was the dark stones, straight lines, and
massive proportions that struck many viewers with awe but
confused them as well, for nothing could be further removed
from the twining limbs and white marble of classical sculpture.
When the Napoleonic wars ended and European governments
established links with Muhammad Ali, a collecting frenzy ensued,
with museums in every capital seeking wonders of their own.
Entrepreneurs like the Italian-born engineer (and one time circus
strongman) Giovanni Belzoni fed the market by bartering with
local governors in Egypt and using indigenous workmen to
cherry-pick tombs and temples, heaving huge statues and
sarcophagi to the Nile for shipment. Belzoni turned his exploits
into a popular book, gave lectures, and mounted exhibits, all of
which helped bring ancient Egyptian art and architecture into the
public consciousness as well as public museums.

Like many 19th century travellers, Belzoni also left his mark in
more tangible ways, carving his name on the monuments he
uncovered—which is how a statue of the goddess Sekhmet, now in
Vienna, came to have Belzoni's name carved above the right side
of her head (Figure 5). The statue is one of two near-identical
pieces donated to the Kunsthistorisches Museum in 1818 by a
businessman who acquired them in the port of Trieste. In fact,
dozens of similar Sekhmet statues, whole or as fragments, can be
found in museums around the world. Unlike faience *shabtis*,

5. Statue of Sekhmet, seated, *c.*1350 BC. Seated statues of the goddess Sekhmet were made in large numbers for a temple honouring king Amenhotep III—one statue for each day and night of the year

however, each statue had to be carved by hand out of the hard granodiorite stone quarried from the Eastern Desert.

Why are there so many statues of Sekhmet? The answer has to do with these particular statues and the temple where they originally stood, as well as the much wider importance of statues in Egyptian art. A statue was a living presence which gave physical form to the god or person it represented, and a special ritual gave new statues power over their senses, like human beings. For non-royal people who had the status to set up statues in their tomb or local temple, a statue was both a memorial and a way to receive blessings and offerings after death. Kings were honoured by countless statues, from small pieces deposited as gifts to the gods, to colossi that became the focus of worship themselves. Statues of the gods likewise came in all sizes and materials: bronze figures dedicated by the faithful, silver and gold-clad cult statues secreted deep inside a temple, portable statues that priests carried in procession on feast days, and solid stone images like the Sekhmet statues.

The Vienna statue in Figure 5 stands almost 2 metres (m) high, including the modern reconstruction of the base and feet. The lion-headed goddess sits on a low-backed throne, favoured for kings and deities; non-royal people usually sit on simpler blocks, or else stand, kneel, or squat. Sekhmet's forward-facing posture, with level hips and shoulders and parallel arms and feet, suggests stillness and stability, though whether these qualities were priorities for the Egyptian sculptors is difficult to say. Certainly rectangular bases with perpendicular back pillars—Sekhmet's rises from the back of the throne to the sun disk on her head—were common to all stone statues. Back pillars often bear inscriptions, but the back of the Sekhmet statue has been left unpolished, in contrast to the high shine of its other surfaces. The only inscriptions (other than Belzoni's graffito) are on the throne either side of the legs, and give the name of the king who had the statues made, Amenhotep III of the 18th Dynasty (c.1410–1372 BC).

The side of the throne also has a motif associated with kings: the hieroglyph meaning 'unite' tied with papyrus stems and river reeds, to symbolize how the king brings the Nile and the Delta together.

As with other Egyptian deities, the representation of Sekhmet is just that, a representation. Such images don't mean that any Egyptian thought his or her gods looked like humans with animal heads stuck on them. Art offers a way to express what can never otherwise be seen with the eye—in this case, the power and beauty of a god. The disk links Sekhmet to her father, the all-important sun god Re. As a lioness, she was ferocious and strong; the name Sekhmet means 'she who is powerful', and she was the goddess who caused, and overcame, war and disease. Over and around her short mane, Sekhmet wears a hairstyle or head-covering similar to that on the *shabti*, which not only marked her divinity but also helped artists transition between the animal head and human body. Sekhmet's attire, comprising a bead collar, straps connected to a long skirt, and anklets, has an old-fashioned simplicity. Together with the *ankh*-sign ('life') she grasps with her left hand, it tells us that we are facing the divine.

Amenhotep III commissioned several hundred statues of Sekhmet either seated, like the Vienna example, or standing with her legs together, holding a papyrus-shaped sceptre. Research suggests that there were originally 730 of each, or one for each day and each night in the year. Like *shabtis*, then, the statues operated on a symbolic or metaphorical level, and had a magical function as well. They originally stood in the vast temple complex Amenhotep III built for his own mortuary cult. The temple lay on the west bank of the Nile at Thebes, fronted by the colossal statues known today as the 'colossi of Memnon'. When the Nile was in flood, water reached the courtyard where the Sekhmet statues and other sculptures were set up. Each statue represented a celestial body, and as it flowed between them, the river brought rebirth to king and cosmos.

More than a century after Amenhotep III died, later kings moved some of the Sekhmet statues to other temples around Thebes, not to desecrate the earlier king's memory, but to make new use of a valuable resource. Belzoni found the Vienna statue, and others like it, in the temple of the goddess Mut across the river at Karnak, and more continued to be discovered in the area throughout the 19th century (one graces the doorway above Sotheby's in London) and up to the present day.

Looking at Egyptian architecture

Some of the seven Sekhmet statues in the Metropolitan Museum of Art in New York still share their space with an actual Egyptian temple—the temple of Dendur (Figure 6), seen by more people today than would ever have seen it in its cliff-top location overlooking the Nile, 50 miles (80 km) south of the first cataract at Aswan. Since 1978, this bijou temple, with the Sekhmets near by, has been the centrepiece of a glass-walled gallery overlooking Central Park, and a popular venue for concerts and parties. Far removed as the temple is from its first home, the specially built annex tries to evoke the original setting, with a stone wall at the back (where the cliffs were), a pool of water in front to recall the Nile, and ample daylight falling on the sunk relief of the outer walls. The temple of Dendur is the largest and most complete example of ancient Egyptian architecture to be found outside of Egypt, and despite its relatively small size—24.6 m from the gate to the back wall—Dendur has many of the features that were common to Egyptian temples for some two thousand years or more. Even Horudja, who served in a temple 400 years earlier than Dendur, and more than 400 miles (690 km) north in the Faiyum, might have found it reassuringly familiar.

Unlike churches, mosques, or for that matter museums, Egyptian temples were not designed as places of communal gathering and shared participation. Instead, the temple was a home on earth for

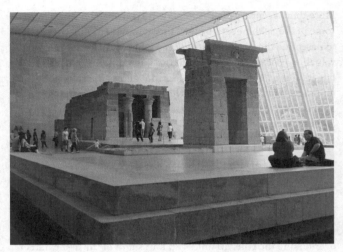

6. Temple of Dendur, *c.*15 BC. Before it overlooked Central Park, this small temple stood high above the Nile at Dendur in the far south of Egypt

the gods whose statues resided in the inner rooms, accessed only by priests. The priests were among the most important men in any town or village, serving in rotas which saw them live 'normal' lives for much of the year alternating with two or three months of temple duty. To carry out the daily rituals performed for each cult statue, sometimes two or three times a day, required a state of ritual purity, which is why later observers (like the Greek traveller Herodotus) singled out practices like not eating fish, shaving body hair, and male circumcision. Most priests were literate as well, unlike more than 95 per cent of the population, and it was through the temple that boys training as scribes could learn their trade and access libraries of ancient scrolls. Temples served their communities in other ways too: they owned land and livestock, channelled goods like grain and textiles, and housed workshops where specialist products, from statues to scented oils, were made.

The architecture and decoration of a temple expressed its symbolic importance, beginning with the stone in which even small, simple temples were built. A high enclosure wall of inferior mud brick, laid in undulating courses, separated the temple from its surroundings and represented the chaos from which the ordered universe—and the temple itself—emerged. A stone gateway fronted the central axis of the temple, just as at Dendur, with its sloping sides and tall cornice; larger temples might have a whole series of these gateways, added as new rulers expanded the complex. Beyond the gateway, an open-air courtyard, which the Metropolitan Museum approximates with a platform, provided space for large gatherings before festival processions, not to mention statues commemorating past priests. Beyond this lay the heart of the temple, which at Dendur consists of an innermost shrine room, an antechamber, and an outer room with a partially open façade, supported by two columns and low walls (known as 'screen walls'), only one of which survives. Between these columns once stood another stone-topped doorway, which is largely destroyed—but its detailed sides still show the patterned ridge (called a 'torus moulding') that framed the edges and a protective, long-tailed cobra at either side. As a visitor moved through the temple, less and less daylight could penetrate, especially when the original wooden doors were in place. The ceiling height dropped and the floor level rose, enhancing the sense of penetrating a secluded space in which the cult statue, in its own locked shrine, would appear for its regular ritual of being anointed and re-dressed in fresh linen.

A temple like Dendur was a microcosm of the world's cyclical birth and rebirth, which Egyptian thought compared to the emergence of dry land as the life-giving Nile flood waters receded. Carved around the bottom of the temple walls are the papyrus plants and other reeds that flourished in the river marshes, and the twin columns represent papyrus and water lily (usually referred to as 'lotus') stems bundled together. At the top of the gateway and over the columns, the risen sun disk appears with bird wings whose

once-bright feathers evoked the brilliance of sunlight. Elsewhere in the cornice, alternating hieroglyphs *tyet* and *djed* stand for the pairing of female and male, since they are associated with Isis and Osiris, respectively; they also confer protection and durability, the approximate meaning of each sign. The relief carved onto almost every surface of the temple looks repetitive—but that was the point. Each carefully composed scene shows the king of Egypt making an offering (of gold, incense, a crown, and so forth) to several gods and goddesses, including the four main deities honoured at Dendur: Isis, Osiris, and two deified men named Pediese and Pihor, who had been the sons of a local ruler in this part of Nubia. Only the Egyptian king could—in art—perform the crucial role of making offerings to the gods, and receiving the country's prosperity in return. This was how the king fulfilled his main role: maintaing *maat*, the sense of order and balance in a universe that—in Egyptian thought—was at risk of disorder and disarray.

The king depicted on the walls of Dendur never saw the temple or set foot in Nubia. In fact, he spent scarcely any time in Egypt at all, for this particular king was the Roman emperor Augustus, identified in the hieroglyphic cartouches at Dendur as 'Caesar', 'Autocrator', or simply 'Pharaoh'. The first two are Latin and Greek terms for a ruler and emperor, spelled out phonetically in the hieroglyphs, while pharaoh (literally, 'great house') was a generic term for the royal residence, rather like referring to the British prime minister as Downing Street. When he defeated Cleopatra and annexed Egypt to the new Roman empire, Augustus faced a series of uprisings in the south, including Nubia. In addition to using military force, he built a series of small temples in the region, marking his succession in the line of kings while also placating both the local people and, for good measure, the gods.

Its original location in Nubia is the reason the Dendur temple now overlooks Central Park instead of the Nile. Since it gained political independence in the 1920s, Egypt had gradually

been scaling back the number of antiquities it approved for export, reversing the colonial-era practice of allowing foreign archaeologists like Petrie to distribute finds to Western backers. In the 1960s, however, plans to build the Aswan High Dam meant that almost 500 km of the river valley in southern Egypt and northern Sudan would be covered by the reservoir known as Lake Nasser. In addition to the enforced relocation of thousands of Nubians, the project meant that several archaeological sites would be lost. Egypt turned to UNESCO for international help, which ultimately saw more than a dozen temples moved to higher ground, most famously the temples of Ramses II at Abu Simbel. As a gesture of thanks, Egypt donated four smaller temples to the US, Italy, the Netherlands, and Spain—giving visitors to these countries a chance to step into an Egyptian temple from the streets of New York, Turin, Leiden, and Madrid.

Displaying the dead

An entire temple may be the most impressive exhibit an ancient Egyptian collection can boast, and a *shabti* or statue the most common—but a mummy is by far the most popular. Even the earliest European collectors relished the prospect of owning a mummy, and although powdered dust ground from the embalmed bodies of ancient Egyptians was widely used as a medicine and a pigment, whole mummies were especially rare. As with other Egyptian antiquities, though, all that changed in the 19th century as adventurers and archaeologists found hundreds of tombs on the desert fringe, stuffed with coffins, mummies, and burial goods.

Some museums divide their displays into 'daily life' and the 'afterlife', because so much of their collection comes from burials. But as we saw above with *shabtis*, most 'funerary' objects had uses outside the tomb as well, and even coffins and mummies, which were exclusive to burials, existed in a network of social relationships and shared values. For one thing, those individuals who were mummified belonged to the most privileged social

ranks. Embalming and wrapping the dead was such a special process that only a few people deserved it. Museums may suggest that looking at mummies on display, and using scientific techniques to investigate them, helps us understand the lives of all ancient Egyptians—but it would be more accurate to say that it shows us the lives of a select few, because of the small percentage buried this way and the even smaller percentage preserved by archaeologists, who kept very few of the bodies they found.

The priest Djed-djehuty-iwef-ankh, whose mummy and coffins belong to the Ashmolean Museum in Oxford (Figure 7), lived and died during the 25th Dynasty (770–712 BC), when the kings of Kush ruled Egypt. His long name is typical of the period; it translates as 'Thoth (god of wisdom) says, may he live'. Part of a family who served the cult of the god Montu, Djed-djehuty-iwef-ankh was buried at Deir el-Bahri, western Thebes, with an elaborate set of nested coffins, two wooden boxes full of *shabtis*, and a wooden stela that shows him offering to the gods Re-Horakhty and Osiris. The museum displays the coffin in a large case with glass shelves to support each lid, so that visitors can see how they fit together. Djed-djehuty-iwef-ankh's wrapped mummy rests inside the innermost coffin, never having been unwrapped, though it has now been CT-scanned; a video next to the display lets visitors view the scan from different angles.

CT-scanning is a technology developed to study the human body—but does the way in which Djed-djehuty-iwef-ankh was buried suggest that his Egyptian contemporaries necessarily saw him as a human, or as a body? The outermost coffin recalls the shape of a shrine, with its arched lid and corner posts. Regularly spaced scenes on the sides show guardian gods, in the same way they appeared on temple walls depicting the protection of the god Osiris. The middle coffin is much plainer in appearance and shows Djed-djehuty-iwef-ankh with a wrapped body, blue-and-yellow striped headdress (like the *shabti* of Horudja), beaded collar, and

7. Outer coffin of Djed-djehuty-iwef-ankh, *c*.600 BC. Nests of coffins enclosed the mummy, like a shrine around a sacred image. This set was made for a priest named Djed-djehuty-iwef-ankh

Egypt on display

a short chin beard. The final coffin echoes the bright white and yellow scheme of the outermost coffin, and to the striped headdress and beaded collar it adds a long, plaited beard of the kind only ever worn by gods and kings in Egyptian art. With each layer of coffins—not to mention the multiple layers of linen, resin, and amulets in place on the embalmed corpse—we get closer and closer to seeing Djed-djehuty-iwef-ankh in the form of a god. Or, to put it another way, all the layers of linen wrappings and nested coffins were designed to keep us away from seeing Djed-djehuty-iwef-ankh at all.

An Egyptian mummy had much in common with one of the cult statues hidden away inside temples for only the priests to see. In fact, the priests who wrapped and anointed mummies had the same title as the priests who dressed and anointed cult statues: 'masters of secrets', emphasizing how restricted the ability to do the wrapping (and to be wrapped) were. Coffins today may look like works of art once they are in museum vitrines—and certainly they are incredibly accomplished—but like many other objects that museums display, this was not how they were originally meant to be used. Museums vary in their approaches to this quandary, depending on each institution's own values and priorities. Balancing public curiosity about ancient Egypt with ethical considerations about the display of human remains and sacred objects (and a mummy arguably is both) is difficult to do.

The coffins and mummy of Djed-djehuty-iwef-ankh show how carefully these objects were designed and decorated, with a dizzying array of images and hieroglyphic texts that attest to their sacred character. All three coffins were made as a set, and the wrapping of the mummy also took the dimensions of the inner case into account, since it fits so tightly inside. Just as mummification techniques and wrapping styles changed over time, so too did the manufacture of the coffins and cases in which mummies were placed. The 'mummiform' coffin first appeared in the 12th Dynasty (around 1800 BC), and from then on was used on its own, in sets, or in conjunction with a rectangular outer coffin. At some periods and places, mummies were fitted with masks, like the mask of Tutankhamun (see Figure 3 in Chapter 1), but this wasn't always the case. Some mummies were buried without any coffin at all, only their wrappings, and the pattern of the wrappings changed as well. Before around the 5th Dynasty (around 2400 BC), many bodies were placed on their sides with the knees drawn up, and were wrapped and coated with resin without any obvious attempt to desiccate the body first. In fact, throughout Egyptian history, the embalming and desiccation of the body is handled quite unevenly, suggesting that the processes

varied. What mattered more may have been the other materials applied and the rituals and prayers that would be carried out while the wrapping took place. If you do visit a display dedicated to 'life after death' in ancient Egypt, keep this variability in mind—and it might also be worth asking yourself, what would an ancient Egyptian have thought, if they could see what you see?

The *shabti* of Horudja, the statue of Sekhmet, and the coffin of Djed-djehuty-iwef-ankh represent three kinds of object you may well be able to see in a museum near you. While the temple of Dendur is more rare, architectural features and fragments can be found throughout Egyptian art and museum collections, because architecture was such an important setting and symbol for ancient Egyptian artists, priests, and rulers, as well as the people who lived in the towns and villages dominated by these buildings. Seeing works of art—and architecture—in person is an excellent way to understand it better, because it lets you appreciate the materials the artist used, the decisions taken about form and design, and the differences of scale, colour, quality, and style. But seeing things in museums is also a reminder of the difference between what the modern world has valued, and the role the same objects had in antiquity.

Chapter 3
Making Egyptian art and architecture

Each object we considered in the preceding chapter required a different set of materials and skills to make it: the mould-made, fired faience for Horudja's *shabti*; the hard, highly polished granodiorite of the Sekhmet statues; the carved sandstone and architectural design required for the temple of Dendur; and the carved, joined, and painted wood of Djed-djehuty-iwef-ankh's nested coffins, not to mention the linen and other materials required to embalm his body. To gain a better understanding of ancient Egyptian art and architecture, knowing more about how objects and buildings were created is important, because every society attaches different meanings to certain materials and technologies, and to the individuals who work with them.

Just as the idea of 'art' emerged in 18th century European thought as a way to distinguish certain cultural products as more refined than others, so too did the idea of the 'artist' develop to separate those involved in making the 'fine arts' (including architecture) from those who worked with 'decorative arts' or 'crafts'. Several factors informed the identity, and public perception, of artists in the 18th and 19th centuries, including the formation of art schools such as the Royal Academy in London, which had a professorship in architecture, and the Romantic movement, with its emphasis on emotive expression and the search for the sublime. In our own era, many people and institutions readily accept that unique

inspiration is what sets a good artist or architect apart from, say, a jeweller or a builder, however skilled they might be. Other societies, however, place a high value on creating works of art and architecture according to established conventions, in which case originality can be a hindrance rather than a help. In ancient Egypt, art certainly did change at different times and places, and with much more innovation than we may recognize from our vantage point today. But Egyptian art and architecture also retained a consistency of form that says much about the priorities of those who commissioned it and about the working lives of those who made it, since these were often two distinct groups.

Many ancient Egyptian objects, not to mention buildings, were the result of a team effort. The coffins of Djed-djehuty-iwef-ankh, for instance, probably required two or three workers to undertake the carpentry of the wooden cases, which had to match closely in fit and appearance. Another set of workers would be responsible for painting the coffins. Given enough time, one person could manage this—and the style on each coffin is consistent—but the stages of preparing the surface and pigments, planning and sketching the design and inscriptions, and executing the painting point to collaboration, for example in a workshop setting. People who worked together formed close bonds and were often family members, with fathers passing their expertise on to their sons.

The cost of a work, as well as its symbolic value, lay not only in the time or skill required to produce it, but in the materials used. Some materials—the clay for pottery, limestone for building materials and sculpture, reeds and palm leaves for basketry—were sourced in the Nile valley, but others had to be obtained through trade or long-distance mining and quarrying. The properties of many materials helped create particular meanings and associations: linen evoked the earth's agricultural cycle, because it derives from the flax plant, while their warm tones, glimmering particles, or translucency meant that red granite, brown quartzite,

and pale yellow travertine (also known as alabaster) drew comparisons with the sun.

This chapter looks at the evidence for how artists, craftspeople, and architects learned their trades and carried out their work in ancient Egypt, which in turn gives us insights into the meanings and relationships that art and architecture helped create in Egyptian society. After considering who these artists were, and how they learned and carried out their work, we return to the question of materials to see how ancient Egyptians exploited the natural world, and early technologies, to craft such a wide array of objects and buildings. The training of artists and the supply of materials they used, even to the extent of re-using earlier artworks, motifs, or buildings, lent a certain consistency to the appearance of Egyptian art and architecture, which may seem at odds with the emphasis Western art has placed on novelty and individuality. It was this very consistency, however, that allowed Egyptian artists to make works that met the needs of their patrons and communities.

Artists in ancient Egypt

Around 2000 BC, a man named Irtysen left one of the most detailed, but enigmatic, statements about being an artist to survive from ancient Egypt. On the limestone tomb stela that commemorates him, his wife, and their family (Figure 8), Irtysen 'speaks' as if from beyond the grave—a narrative form that was common in non-royal contexts and that allowed men (and they were always men) to present a model narrative of their accomplishments. Irtysen identifies himself as 'a craftsman who excels at his art and has a superior level of knowledge'. He elaborates exactly what this knowledge is: how to estimate dimensions, how to make things fit in a design, and how a male and a female statue should appear, as well as an array of details—eleven birds of prey, the look of fear on an enemy's face, the stance of a hippopotamus hunter—that are strikingly specific,

8. A 19th century line drawing of the stela of Irtysen, *c.*2000 BC. In the 19th century, detailed drawings helped scholars record and study objects like this stela, which commemorates the artist Irtysen and his family

and in some cases difficult to reconcile (a squint, for example) with works of Egyptian art we know today. Irtysen also knows how to mix pigments and melt precious metals, and most important of all, he boasts that he knows the 'secret' of writing, the performance of rituals, and 'all the magical formulae'. 'There is nothing I don't know about them,' he says, to emphasize the point.

Because so much of what we characterize as art—that is, objects that were made with care and held a significant cultural meaning—related to the world of the gods and their temples, artists became privy to powerful, sacred, and hence secret information. Their work itself was part of this: fusing silica, soda, and pigments to make glass and faience, transforming molten lumps of metal into sculpture, and giving physical form to the hieroglyphic inscriptions and carved or painted scenes that brought the gods' power into this world.

The word Irtysen uses to refer to himself is *hemuty*, usually translated as 'craftsman'. The hieroglyphic sign for this word was a rotating drill, of the kind used from around 3500 BC onwards to drill the cores out of vases and bowls made from richly coloured and patterned stones (see Figure 10 later in the chapter). Irtysen also uses the word *qesty*, or 'sculptor', written with the harpoon symbol, which may refer to the hippopotamus ivory used for predynastic carvings, since these animals were hunted with harpoons. Perhaps the most common word for sculptors was *s-ankh*, which meant 'causing to live'—a revealing phrase for understanding how ancient Egyptians thought about statues, which were 'alive' once they had been properly created and ritually activated. Relief sculpture on temple walls could also be 'alive' in this sense. From later sources, we know that relief sculptors and painters were known by variants of the word *sesh*, for writing. No word from ancient Egypt translates easily as 'architect', at least not in the way we understand the role of designing a building. High-ranking officials called 'overseers of the king's works' probably carried out some of the tasks associated with large-scale construction.

However much Irtysen emphasizes his skill and social status, many artists and craftspeople in ancient Egypt lived and worked in conditions of routine, and often arduous, physical labour. The hard work involved in many trades was spelled out in a school text that boys copied when they were training to be scribes: coppersmiths had fingers like crocodile skin, sculptors had to keep working by lamplight no matter how weary their arms, and jewellers, who drilled and cut the hardest semi-precious stones, were hunched double with exhaustion. Training as a scribe was the key to a good life, since the ability to read and write opened doors that were closed to most of the population.

The importance of writing and drawing are evident in the remarkable records of Deir el-Medina, a small village in the desert on the west bank of the Nile opposite Luxor. During the period known as the New Kingdom, the village was home to the artists who decorated tombs in the Valley of the Kings, together with their families. In excavations over the past century, the village has yielded not only the houses and tombs of these workers, but also copious documents about their lives, from roll calls at work, to laundry lists, to mortgages and police complaints. The draughtsmen and painters worked in gangs under a more experienced overseer, rather like the large groups of *shabti*-figures discussed in Chapter 2. Since they were working on royal tombs, these artisans were at the very top of their profession, but the work was still hard: the men hiked over the mountain behind the village each day to reach the tombs, where they might be working deep underground painting walls and ceilings. Many also worked in the village, decorating each other's tombs and creating objects for their own use, or on commission.

Evidence from the village has helped identify one of these accomplished artists, a man named Amenhotep who had a long career in the 20th Dynasty (*c.*1170–1130 BC). Amenhotep was a draughtsman, scribe, and low-ranking priest, who is known

9. **Sketch on limestone by the draughtsman Amenhotep, *c.*1100 BC. An artist named Amenhotep drew this image of himself praying, surrounded by the words of a prayer to Thoth, god of wisdom and writing**

through several limestone flakes that scholars call by the Greek word *ostraca*. Quarrying activity meant that these flakes were copious, so artists and scribes had them easily to hand as sketchbooks, doodle pads, and even prayer offerings. An *ostracon* almost certainly drawn by Amenhotep himself shows him kneeling in prayer to Thoth, god of writing and wisdom (Figure 9). The lines of the drawing are fluid and unbroken and the handwriting flows with ease. Folds of flesh under his chest and a soft belly with a triangular, peaked navel show Amenhotep as a mature and successful man. The same soft belly and triangular navel appear on other drawings by Amenhotep—and on a ceiling in the tomb of king Ramses VI, showing the star-spangled body of the sky goddess Nut stretched over the space where the king's massive sarcophagus and nested coffins would lie. The tell-tale shape of the goddess's navel puts Amenhotep on the scene, but such a complex work required the input of several men and months of effort spent cramped on scaffolding. Amenhotep the draughtsman may be the Michelangelo of ancient Egypt—but like Irtysen before him, he was part of a larger community of artists trained in time-honoured methods.

Walking the line

Even though it is rarely possible to link a named artist to a work he produced, as with Amenhotep and the tomb of Ramses VI, features of style, iconography, and content enable scholars to identify works of art and architecture with a certain region or a specific time period. In the same way, it is often possible to group artworks together as the products of a single, albeit hypothetical, workshop. Collaborative methods were crucial to the creation of buildings, wall paintings, sculpture, and many other objects. Members of a local community probably knew which workshop was responsible for a given building or statue, and may have preferred one over another; however, nothing in the ancient record explicitly tells us this.

As we saw with the tomb painters at Deir el-Medina, the best quality works were produced for the king. Groups of builders and sculptors attached to royal workshops could move throughout the country if needed, working at different sites. The king also had a monopoly on certain materials, like red granite from Aswan. In the Old Kingdom, inscriptions in the tombs of royal officials acknowledge the privilege bestowed on them by the king in supplying their granite sarcophagi, for instance. Where someone's tomb was located and what objects it contained were not so much the result of individual choice and expenditure, but of social norms and available supplies, both of the materials themselves and the craftspeople to work them.

From around 3100 BC—not coincidentally, the same time the hieroglyphic writing system began—Egyptian art and architecture adopted a conspicuous form, or outward appearance, which is especially obvious in images carved or painted on a flat, two-dimensional surface. This consistency contributes to the stereotypical or humorous idea today that ancient Egyptians walked with their arms akimbo and legs awkwardly turned, both feet facing forwards. Even a more fluid or informal-looking composition like the *ostracon* of Amenhotep (Figure 9) displays many of these characteristics: his face, arms, and lower body are in profile, he seems to have just one leg (because he kneels with them together) and two left hands (since the thumbs face the viewer), and his torso shows the viewer both the profile of his chest and the front of his navel and belly.

In fact, Egyptian two-dimensional representation used artistic solutions identical to those developed independently in ancient Babylonia and Assyria, Greece before the Classical period, India, and the Americas, for instance in the Aztec and Mayan cultures. Combining profile, frontal, imaginary, and bird's-eye views allowed for visual clarity in the way that perspective, which was favoured in classical Greece, Rome, and Renaissance Europe, did not. Sometimes called 'aspective', ancient Egyptian and similar

forms of art acknowledged the flatness of the picture surface, rather than trying to fool the eye with foreshortening, shading, and other tricks to make it resemble three-dimensional space.

The development of hieroglyphic writing and artistic conventions were so closely entwined that it would be meaningless to separate the two. Around the time that a centralized state emerged in the Nile valley, a major shift in material culture also occurred, as if earlier forms like the Min statue (see Figure 1 in Chapter 1) were purposely rejected in favour of a bold new visual idiom. The pictorial writing system, which combines hieroglyphs that represent sounds and concepts, was an art form in itself, and it had a major impact on the design of objects and buildings alike. Two-dimensional images based on hieroglyphs, like the sign for a man, were extrapolated into three dimensions, so that a statue of a man likewise had the left leg advanced (see Figure 2 in Chapter 1), just as it would appear as the 'far' leg in the dominant, right-facing position of Egyptian art and writing (see Figure 18 in Chapter 5). Hieroglyphs and other images could be flipped to face left when context required it—for instance, to have symmetrical figures either side of a temple doorway—but this did not extend to changing the stance of statues, which always have the left leg forward. In paintings and relief, hands and feet often stayed the same as well, which helps explain Amenhotep's interchangeable hands.

Whereas perspective-based art uses differences in size to indicate distance in space (larger figures are 'closer' to the viewer, smaller ones farther away), ancient Egyptian art used differences in size to show status: the taller the figure, the more important that person was in relation to anyone else represented, with the result that female family members, children, and servants would all appear shorter than the man who owned a tomb (see Figure 16 in Chapter 5). Since Egyptian gods and rulers wear a variety of crowns, making some taller than others, artists used the top of the forehead—human or animal—to line up equal-status figures,

regardless of whether they were seated or standing (see Figure 13 in Chapter 4). The organization of images was also important in this respect. On the wall of a temple, for example, there were several horizontal divisions, which Egyptologists call 'registers'. Each register had its own internal logic as well as relating to the register above and below it; generally speaking, the higher the register, the more important the scene or person represented. Until around 1300 BC, only the king could appear on the same register as a god. Less important figures and objects can appear on an additional 'floating' ground line within the register, or as a shorter, subsidiary register next to it.

Composing the wall and ceiling scenes for projects like the royal tombs, or large temples, required special coordination to accomplish all the work in time. Not only did the designers have to be familiar with a range of do's and don'ts, including the arrangement of registers, but they were also often working in confined, dimly lit spaces. Horizontal guidelines were an essential tool, providing the ground line on which figures 'stood' in each scene as well as other shared coordinates, such as the forehead height. From the Middle Kingdom, artists began using a whole grid of evenly spaced squares, traces of which sometimes survive on unfinished work or where paint has flaked away. Each square was approximately the width of a figure's palm, and standing figures were 18, 20, or 21 squares high, depending on the time period.

Grids helped artists execute figures of identical proportions, position hieroglyphic inscriptions, and organize the decoration of adjacent scenes and walls. Although grids were also useful for copying, by allowing artists to scale a scene up or down, this was not their primary use in Egypt. Instead, the grid technique assisted artists in attaining the clear and balanced compositions that the Egyptian system of representation required. Such compositions were a visual expression of *maat*—the ideal, cosmic order. Sculptors also used grids, since Egyptian statuary treated

the four planes of each piece—front, back, and sides—almost independently, working inwards from each side of a rectangular block. Small adjustments in the use of the grid also yielded subtle changes in style: placing the waist a square higher or lower would elongate either the legs or the torso, respectively, and allowed the change to be replicated easily by other artists in a workshop.

However similar Egyptian art may look at first glance, thanks to the rules that artists were trained to follow, it did change considerably over time, with each era developing stylistic preferences and new ideas about what it was appropriate to depict. Artists and craftspeople were also quick to embrace the possibilities of working with different materials and technologies—some of which can scarcely be imitated today.

The material world

As we saw above on the stela of Irtysen, the hieroglyphic sign for *hemuty*—a generic term for an artist or craftsman—was a bow-operated drill of the kind used from predynastic times to create vases from solid blocks of stone (Figure 10). This association between stone-working and art seems to have been significant in ancient Egyptian thought, and vases like those in Figure 10, used for precious oils and ointments, continued to be high-prestige items for thousands of years. Such vases were made in a variety of stones valued for their colours, patterns, and veining, which were sometimes imitated in paint on jars made of pottery or wood. Paradoxically, with their rounded bodies, flat rims, and tubular lugs for rope handles, the stone vases themselves imitate ceramic pots, turning an expendable, everyday item into a permanent, luxurious one.

The stone vases and their wooden and pottery 'twins' highlight the important role that different raw materials play in a society. The materials available to craftspeople, the ways they are worked and qualities they have, and how society uses the objects and

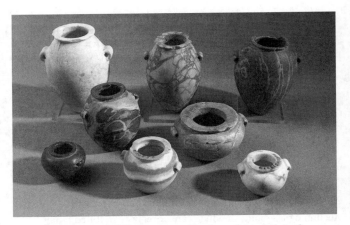

10. Group of vases in different stones, Predynastic period. In the fourth millennium BC, when these vases were made, Egyptian craftsmen were highly skilled at working stone quarried from the deserts

structures that result, all contribute to what anthropologists and archaeologists term 'material culture'. This phrase is not a synonym for objects or things; instead, it refers to a way of thinking about the relationship between things and people. People make things, but things make people, too, because the material world and the built environment require social, political, and economic interactions. Take tea drinking in Britain as an example: developed as a result of colonial expansion, and today, through international trade, it requires specific materials and objects, and in turn facilitates human encounters at every level of society.

In ancient Egypt, materials, products, objects, and buildings will also have had culturally specific uses and meanings, which the study of art and architecture can help recover. The natural environment of the Nile valley made several raw materials available to Egyptian makers: flax for weaving linen; palm leaves for basketry; silty clay deposits for pottery; indigenous trees like

the sycamore fig and acacia, for carpentry and sculpture; and salt lakes north of the Faiyum, for the natron used in faience. The adjacent desert regions, especially to the east, expanded this to include lime-rich (marl) clay; minerals like hematite and galena (a lead ore used in eye paint); copper, tin, and gold; and a rich array of stones. Other materials, such as cedar, ebony, ivory, and silver, were obtained through trade routes that connected Egypt to her neighbours in Africa and around the eastern Mediterranean; lapis lazuli came from as far away as Afghanistan. Materials from far-flung places, and from desert regions where the gods themselves were thought to dwell, added the mystery of the world's creation to the creative act of making art.

To meet the demand for stone, ancient quarrymen exploited sources throughout Egypt and northern Sudan. The eastern desert, which was rich in minerals and metals as well, supplied stones for jewellery, vases, and sculpture, including yellow, green, and red jasper; blood-red carnelian; grey-green greywacke; speckled black serpentinite; and creamy yellow travertine, commonly known as Egyptian alabaster. From the Faiyum came dark, smooth-grained basalt, and from around Aswan the distinctive red and pink granites, whose crystalline structure glistened in the sun. Aswan, Sudan, and the Nubian deserts were also the source of many dark grey and black stones, such as granite, granodiorite, and anorthosite gneiss, whose colour was reminiscent of the silt deposited by the Nile flood. In the Nile valley itself, limestone provided a ready material for building blocks and sculpture, complemented by sandstone quarried in the upper reaches of the river valley, stretching into Sudan.

The development first of faience and later glass was a technological triumph, allowing craftsmen to create products that were valuable in their own right but also as imitation stones. Egyptian craftsmen manufactured glass from the New Kingdom, achieving hues of white, yellow, green, red, and blue by adding different mineral pigments, including cobalt retrieved by

state-sponsored expeditions to the western oases. The opaque colour and consistency of glass (which differed from the surface glaze of faience) made it especially desirable and stone-like; one Egyptian term for it was 'stone that flows', referring to its molten state. Glassmakers swirled hot glass around a disposable core to make jewel-like vases, sometimes trailing colours together in swirled bands.

Metalwork using bronze and other copper alloys was another skilled craft, not to mention the virtuoso silver- and gold-smithing preserved in the highest-ranking burials. Where metal objects were cached in temples, they escaped being melted down and recycled—the likely fate of any metal found by tomb robbers. Controlling the exact composition of the metal and, for bronze, the stages of the lost-wax casting process allowed artisans to create different colours and finishes. Bronze statues emerged from their moulds with a copper-brown or silver-black sheen, to which inlaid stone eyes or gilding could be added. Like the gleam of glass surfaces and highly polished stones, the shining surface of metals held particular appeal, marking out these materials—and their workmanship—as something special, almost otherworldly in the way they came into being from raw elements and skilled execution.

In a culture where every process of manufacture was just that—made by hand—more humble materials also had cultural value due to the materials and labour that went into creating them. In tomb scenes of artists and craftspeople at work, the carpenters, stonemasons, and metalworkers are male; however, women were involved in many kinds of making too, even though their voices and representations rarely appear in the ancient record. At different stages, many crafts could involve both genders and all ages, from keeping an eye on the pottery kiln to preparing palm leaves for basket-making. The craft most closely linked to women was the production of linen textiles, which were an integral part of society. Made from the core of flax stems, which

girls and women spun into thread, linen came in grades from 'royal' cloth, so fine it was almost sheer, to everyday weaves for household use. Women did most of the weaving, a role the goddesses Tait, Neith, and Isis and Nephthys assumed in Egyptian mythology. Because of its association with women, and its plant origin, linen symbolized rebirth, which made it an essential part of religious rituals like dressing cult statues and wrapping mummies. Even though women were excluded from significant roles in temple hierarchy, the product they made linked the gods, the living, and the dead.

Everything old is new again

On the stela of Irtysen, which we considered earlier in this chapter, the inscription closes with Irtysen announcing that he will pass his artistic knowledge on to his eldest son. In the fashion of these narratives, his choice is credited to the gods, but in fact, it was common for trades to pass down through generations. Family relationships were the basis not only for arts and crafts carried out by men, but also those associated with women, such as spinning and weaving. Although technological advances occurred, and were often quickly adopted, learning a skill from the previous generation ensured a certain continuity of methods and techniques. Likewise, the ways in which draughtsmen, painters, and sculptors were trained and worked encouraged a similarity of form as well. This gave Egyptian art and architecture its consistent appearance, but changes in style and content, and in how images or buildings were made and used, must have been more evident in antiquity than they are today, when we rely on our own eyes—and a depleted material record—to make sense of such a different visual world.

One striking feature of elite culture in ancient Egypt is that it repeatedly invoked its own history and looked to the past for artistic inspiration—an embrace of tradition that allowed later generations to step into positions of power by reasserting the

legitimacy of an earlier model. For instance, when a king described the glory of a temple he had built, he would not boast about its innovative design. Instead, he would proclaim that he built the temple in the same way temples had always been built—just bigger and with better, more splendid materials. Doing things the 'right' way meant doing things the old way or, at least, in a way that convincingly appeared to be old.

Temples were remade over time, by knocking down and rebuilding previous structures as well as extending outwards, adding new courtyards and gateways to the earlier core. Later kings could add to their own status by revising or completing a previous ruler's work. At the temple of Amun at Karnak, the 18th Dynasty king Amenhotep III (*c.*1360 BC) began construction of a new gateway facing south, along a processional route leading to Luxor temple. Known today as the 10th Pylon (see Figure 11), the gateway was finished some fifty years later by Horemheb, a general who became king in a period of transition following Tutankhamun's early death. His non-royal origins may have made Horemheb keen to embark on kingly projects; he was also pivotal in destroying the work of Amenhotep III's successor (and Tutankhamun's likely father), Akhenaten. Horemheb had Akhenaten's own temples at Karnak dismantled and used as fill inside the 10th Pylon—both a practical solution to dealing with rubble and an effective way of neutralizing an undesirable part of past.

Along the base of a colossal statue of Horemheb (originally made for Amenhotep III) that backed against the pylon, facing the processional way, archaeologists in 1913 discovered four granodiorite statues of men seated as scribes, each cross-legged and holding a pen to the papyrus scroll he has stretched across his lap (Figure 11). The two statues on the left represent Paramessu, a high priest of Amun and 'vizier' (chief advisor) who succeeded Horemheb as king Ramses I, grandfather of Ramses II 'the Great'. The two statues on the right belong to the reign of Amenhotep III, who started work on this gateway. They were

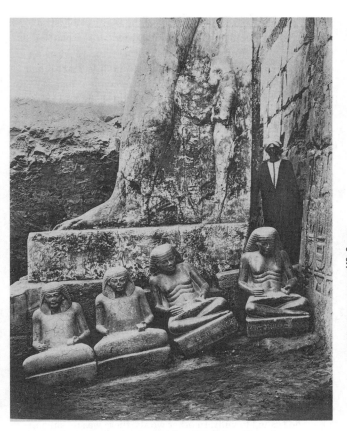

11. A 1913 photograph of statues at the 10th Pylon, Karnak.
Archaeologists working at Karnak temple in 1913 found several statues
lined up as they had been for centuries, outside a large gateway

moved here from another part of the temple and are among
several statues representing the king's 'overseer of royal works',
Amenhotep the son of Hapu. This Amenhotep was a renowned
wise man commemorated as a demi-god after his death.
Paramessu's statues echo Amenhotep's in many ways: the pose,

plinth, stone, and size, plus the style of the face and hairstyle, which layers wide ridges of curls over tighter curls or plaits. But the statues differ from each other as well: Paramessu wears an official vizier's garment covering his torso and legs, and his hair falls to the front of his shoulders, while Amenhotep wears a knee-length skirt, baring the rolls of fat on his belly, and his hairstyle falls behind his shoulders. To complicate things further, Amenhotep's statues were themselves inspired by a series of scribe statues made in the 12th Dynasty (c.1900 BC) for an official named Mentuhotep, which had already been standing in Karnak for centuries.

When Egyptian artists look to works from the past for inspiration, Egyptologists characterize the result as 'archaism', meaning an artistic style that looks old-fashioned on purpose. But the examples of the Karnak scribe statues—first of Mentuhotep, then Amenhotep son of Hapu, and finally Paramessu, the future king— suggest that revisiting and reviving older models was a complex phenomenon. Each statue managed to evoke the authority of the distant (and not-so-distant) past while also being of its own time. The colossus behind the statues was made for Amenhotep III but re-inscribed (or 'usurped', some scholars say) by Horemheb, who nonetheless left the older king's name untouched on the lower courses of the 10th Pylon. In completing the gateway, Horemheb created his own scenes and inscriptions to complement the earlier ones, while stuffing the inside with the stone vestiges of a king he wished to vilify. In other words, there was no single, predetermined relationship between ancient Egypt and its past. The past is created in the present, so each instance of 'archaism' must be seen as the product of its own time. Re-use, revival, or re-interpretation may be more precise and helpful words for discussing art and architecture that makes a knowing nod to earlier forms and styles.

The statues of Paramessu and Amenhotep son of Hapu demonstrate the depth of historical knowledge Egyptian artists

possessed, alongside their technical proficiency and aesthetic sensitivity to harmonious compositions and high finish.

Artists like Irtysen, Amenhotep the draughtsmen, and their countless, nameless colleagues were not the tortured geniuses of modern European art. Instead, they were specialists who learned their trade from a young age. The most prestigious crafts—architecture, stone sculpture, painting, metalworking, and glass manufacture—depended on the patronage of temples, local elites, and the king himself. Some art forms, materials, or technologies involved restricted access, either because the materials were effectively a royal monopoly or because the religious character of an artwork required secrecy in its making and use. At the same time, many other craft forms—pottery, basketry, textile production, or wood, stone, and faience objects that appear simplistic or odd to viewers today—were just as integral to ancient Egyptian life. Through the processes of making, using, and exchanging material goods, humans created relationships among themselves, and with the gods.

Chapter 4
Art and power

Hunkered over their papyrus scrolls, the statues outside the 10th
Pylon at Karnak may seem oblivious to the colossal figure of the
king behind them (see Figure 11 in Chapter 3)—but their owners
and makers were anything but. The king of Egypt stood at the
pinnacle of the social hierarchy, in a position that uniquely
allowed him to communicate between the people and the gods.
He was in effect a god on earth, who dwarfed his subjects in
every sense.

The king's power manifested itself through art and architecture,
from colossal statues to small vases and trinkets inscribed with
royal names, not to mention the temples in every Egyptian
town, all of which featured kings past and present. As we saw
in Chapter 3, many prized materials and the best quality
workmanship fell under royal control. Being able to access such
products was a distant echo of having access to the king himself,
so that the king—who was a real person, but so much more than
that—could be shared out among the people and places he ruled.
In a similar way, a piece of jewellery marked with the royal
cartouche (the oval around a ruler's name, framed by a knotted
rope) brought the king's beneficial power to its wearer. Lower
down the ranks of Egyptian society, some officials mimicked the
status of the king by erecting their own statues or grand tombs,
adapting royal artistic privileges to a local level. Nor did non-royal

origins prevent some men, like Horemheb and Paramessu, from assuming the throne themselves.

The role of kingship was more important than any single king, as the decorated walls of temples made clear: there, in almost endless repetition, the king offered gifts to the gods in exchange for their continued good will towards the land and the people of Egypt. Egyptian temples were earthly homes for the gods, not places for worshippers to gather as they would in a church, mosque, or synagogue. The temple was off-limits to everyone except the king and members of the priesthood, who had to be in a state of purity before entering. High walls and gateways, like the 10th Pylon, set the temple off from the outside world. The statues of Paramessu and Amenhotep son of Hapu, seated at the feet of the royal statue, are on the outward-facing side of the pylon, oriented south along the road leading to another temple. People who were not permitted to pass through the gateway could at least approach the statues of the king and his faithful retainers—whose papyrus scrolls are worn down from generations of devout visitors stroking the stone surface. If the king acted as intermediary between people and gods on a larger, cosmic scale, these men— through their statues—filled a similar role for more modest purposes. Around the base of the two Amenhotep statues, the hieroglyphs read as if he were speaking: 'O people of Upper and Lower Egypt, come to me so that I may report what you say to Amun in Karnak. I am a herald whom the king appointed to listen to prayers.' Spheres of power that might seem separate—the spiritual and the economic; the king, the priesthood, and local big-wigs—were closely connected in ancient Egypt, which is why Amenhotep credits the king for his prayerful prowess.

This chapter considers how works of art and architecture channelled power in different ways, starting with the imagery that surrounded the Egyptian king. As the embodiment of the god Horus on earth, the king had heavy responsibilities as well as superhuman qualities to help meet them. Understanding how the

king and the gods were represented in art helps make sense of many kinds of objects and buildings, including statues, stelae, and temples. Temples were repositories not only of artworks and workshops, however, but also of food and products, written records, and that always important commodity—know-how. The flow of goods and knowledge connected the temple, and thus the king and the gods, to the lives of more ordinary Egyptians, which we can glimpse through objects used for magical rites and personal devotion. Rather than seeing representations of 'everyday life' when we look at Egyptian art and architecture, we are often looking at the way art was used to negotiate power relationships between human beings in a complex, stratified society, and between human beings and the world of the gods.

The mighty Horus

Egyptologists are fond of old-fashioned words, thanks in part to the 19th century roots of the organized study of ancient Egypt. To smite—that is, to strike someone down, especially with a hand-held weapon in battle—is one example of a word that was more common a century ago (especially to English speakers steeped in Biblical language), but is rarely used today. However, specialists in Egyptian art speak about the 'smiting scene' as a shorthand way to identify images of the king raising a weapon against a cowering captive (Figure 12). This stock composition appears from the beginning of the so-called Dynastic period—when a single ruler seems to have gained control of the Nile delta and river valley—to the era of Cleopatra's dynasty almost three thousand years later. Any image in use for such a long time, and in so many contexts, must have done a good job of conveying valued ideas, and ideals, in an adaptable way.

The 'smiting scene' in Figure 12 has been incised with a fine tool on a thin square of hippopotamus ivory, just over 5 cm wide. The two bottom corners were cut off at neat angles, and a hole pierced in the top right allowed this label to be tied to

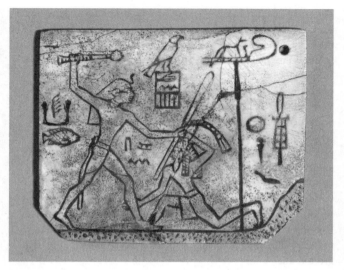

12. Ivory label of king Den 'smiting' an enemy, *c.*3000 BC. This small ivory label was made to tag a pair of sandals in the tomb of king Den, who is shown in the act of clubbing an opponent

something—probably a pair of sandals, because that is what the artist also carved on the reverse. Labels like this one have been found by the dozen at Abydos, a site in southern Egypt (around 500 km south of Cairo) where splendidly supplied tomb complexes housed the burials of the first Egyptian kings to rule a unified, territory-based state. Abydos lay on the west bank of the Nile, at an intersection with travel routes west to the desert oases and east to the Red Sea. Between the agricultural fields along the river and the mountains of the high desert, these early rulers built mud-brick tombs filled with the riches of the day: weapons, jewellery, linen, furniture with ivory fittings, and stone vases and clay pots containing resin, oil, and food. Seal impressions mark some of these products as state-produced commodities, and the ivory labels may serve a similar function, both bureaucratic—to identify and tally goods—and symbolic.

The scene on the sandal label is a well-balanced composition, with the body of the standing figure—the king—the same distance from the left side as the upright, jackal-topped pole is from the right. In between, the figure cowering at the king's feet raises his arms helplessly beneath the scene's central element: a rectangle enclosing hieroglyphic signs, on top of which a falcon seems to perch. This is no ancient bird bath, though, but a carefully devised system for writing the name of the king, which reads Den. The rectangle represents an enclosure, perhaps a royal residence, whose façade was covered with basket-weave matting, depicted as stripes in the lower third. The two hieroglyphs—a hand and a squiggle of water—have the phonetic values D and N; vowel sounds were rarely written. The falcon represents the sky-god Horus, inseparable from the palace and the king. Together, they claim dominion over the entire world, including the inhospitable deserts depicted by the sand-strewn ground line.

The figure of king Den faces right, like the falcon. He radiates royal power through his strong body, clothed in a skimpy skirt and a head covering that falls down his back. The tail of a bull is tied to his waist, and a cobra rears up at his brow. He is barefoot as he grasps a mace in his raised right hand; in his left, he holds a long staff and grabs the hair of the prisoner, whose beard contrasts with the clean-shaven ruler. On the other side of the pole—one of several royal standards that accompanied and protected the king—a group of hieroglyphs reads 'smiting the East'; the entire scene can be 'read' the same way. To the far left, next to the king, a word ending in a fish symbol is the name Inka, perhaps the official who labelled or donated the sandals for the royal burial. The resources spent on the tombs were not just about the king, but about an entire social sphere that depended on him.

Looking at such an early depiction of kingship, it is difficult not to project backwards from later symbols and images, which could

make us apply meanings not intended in the 1st Dynasty. At the same time, there are striking consistencies with much later representations of kings, not only the smiting action itself, whereby the king defeats the enemies (real or imagined) around Egypt's borders, but also the royal standard, the prominence given to the king's name and body, and the cobra on his brow, called a 'uraeus' after the ancient Greek version of its Egyptian name, *iaaret*. Although the rectangular enclosure (*serekh*) around the main royal name was eventually replaced by the looped cartouche, every ruler still embodied the god Horus on earth. When they came to the throne, kings acquired four names in addition to the name they had been given at birth. Since ancient Egyptian names comprise phrases or entire sentences, this long chain of names and titles expressed each ruler's new and unique identity, a sort of mission statement for his character and accomplishments. The first three names, which were not in cartouches, associated him with the gods: first, The Horus, then The Two Ladies (the vulture and cobra goddesses of southern and northern Egypt, respectively), and third, The Golden Horus. The fourth name, written in a cartouche, was the name most Egyptians knew the ruler by. It followed a title usually translated as 'king of Upper and Lower Egypt' or simply 'the dual king', which referred to the foundation myth of the Egyptian state and the pressing obligation each king had, to keep the delta and valley regions united. Last but not least, since it is the name we know the kings by today, the fifth name also appeared in a cartouche, preceded by the phrase 'son of Re', the sun god. To give an idea of what a complete royal title (or titulary) looked like, one king was officially The Horus 'Strong bull, beautiful of births', He of the Two Ladies 'Law-giver who calms the two lands and pacifies all the gods', The Golden Horus 'Appearing in regalia, who pacifies the gods', Dual King 'Lord of Re's manifestations', Son of Re 'Living image of Amun'—in other words, Tutankhamun.

As their complex titulary shows, the kings of Egypt combined in one human body a set of divine characteristics and sole

responsibility for the country's well-being. Thus the king's body—its care and adornment, its representation in art, and its safety—was an important concern, which Egyptian art explored in many ways. What the king wore—like the sandals to which Den's ivory label was tied—became an expression of his royal and divine nature. Sandals were status items, but in art, the king is regularly barefoot, too, like the gods. Kings will have dressed in the finest clothing: the best quality linen was called 'royal' linen after all, and Tutankhamun's burial included a wardrobe's worth of matching underclothes, embroidered and sequinned tunics, and fine gloves. But what appears in art does not necessarily match what was worn in real life. Artists always had to consider cultural priorities about what an image should, or could, depict in any given context, and styles of both clothing and art changed over time. In the New Kingdom, for instance, kings appear in armour and military regalia, especially in temple scenes that show off the recent adoption of the chariot for warfare. King Tanwetamani (see Figure 2 in Chapter 1), and perhaps Den as well, wears the most typical and enduring royal costume, the skimpy *shendyt* skirt designed to reveal a strong and youthful body. Only in a festival of renewal, called the *sed*, are kings shown with their bodies covered up. During the ceremony, they wore a tightly wrapped linen cloak while they were anointed with oil and perfumed with incense—the same procedures carried out to wrap and mummify the dead. Afterwards, the king removed the cloak to show off his reinvigorated body, whatever his actual age.

Perhaps the most noticeable signs of kingship are the cobra on his forehead, which warded off danger, and various head coverings and crowns, each symbolizing some aspect of the king's role. No actual examples of the more elaborate crowns survive, making it difficult to say exactly how they were made, but a basketry framework covered with cloth and embellishments would have done the trick, likewise something made of leather or beaten metal. The Egyptian word for a crown meant 'manifestation', that is, the visible form in which something divine appeared. The same

word appears in the fourth name of Tutankhamun and derives from the verb 'to arise' or 'to appear', used to describe the movement of sun, moon, and stars—and the arrival of the king, the mighty Horus come to earth in human form.

Temples and society

Understanding the king's divine nature helps us to appreciate the role temples played in ancient Egyptian society. Temples provided earthly homes for images of the gods, whose cult statues were cared for by priests deep inside the stone-built sanctuaries that survive today. A temple was much more than a place of ritual, however. Both inside the sanctuary and in the mud-brick offices, workshops, and residential quarters that filled the walled temple precinct, the priests helped oversee the administrative, economic, and cultural life of the country. Temples were in effect the apparatus of the state—a tax office, land registry, and exchange rolled into one. They also functioned as schools, archives, and living museums, repositories of Egyptian high culture through the artworks they accumulated and the libraries of papyrus scrolls they housed. The fact that so few of the population were literate ironically made written records all the more important, because those who could read, write, and control them wielded considerable power.

The longest papyrus scroll ever discovered is known as the Great Harris Papyrus, after the British merchant who bought it in Egypt in 1862 (see Figure 13). Now in the British Museum, where it is divided into sections mounted between sheets of glass, the papyrus measures 42 m long and some 40 cm high. Papyrus was made from the long fibres inside the stems of papyrus plants, thin strips of which were pressed together at right angles, left to dry, and trimmed to size; it was a valuable material, often erased and re-used over time. Long sheets of papyrus were rolled up in scrolls which—like those depicted on the Amenhotep and Paramessu statues (see Figure 11 in previous chapter)—could be

13. Ramses IV and the gods, Papyrus Harris I, *c.*1200 BC. Part of one of the longest papyrus rolls ever found, this painting shows king Ramses IV addressing the gods of ancient Thebes

unrolled from right to left, following the direction in which ancient Egyptian scripts (like Arabic and Hebrew today) were written. Most papyri use a script called hieratic, a sort of cursive version of hieroglyphs that scribes could write quickly, and often quite elegantly, with a brush pen made of thin reeds whose ends were chewed to soften them. As we've seen, pictorial representation and the written word were almost inseparable in ancient Egypt. It was therefore entirely in keeping that the Harris Papyrus—which records historical events as well as long lists of donations king Ramses IV made to three major temples—should also include beautifully rendered scenes of the king announcing to each temple's resident gods what he has done for them.

In one of the scenes, drawn and painted to use the full height of the papyrus, the king is at our far right, facing the trio of deities who stand in the more important, rightward-facing direction (Figure 13). As near equals, the king and the gods share the same ground line and are the same height at forehead level. They also

have the same 'skin' colour, a blinding white that represents their ethereal glow, not a skin tone. The cartouches near Ramses' head encircle his fourth and fifth names, while the two columns of hieroglyphs below contain the words he speaks to the gods, matching the oratory gesture of his open right hand. From right to left (nearest to farthest from the king) are Amun-Re, the chief god of Thebes; the goddess Mut, meaning 'mother'; and their 'son' Khonsu (the name means 'wanderer'), a moon-god who could appear with either a human or a falcon head. Organizing gods into these families, or triads, reinforced ideas of the life cycle and continuity across the generations, the child-god being born anew to carry on its parents' work, like the king carried on his.

It isn't only their glittering skin that makes Ramses and the gods look so splendid, but the regalia they wear and carry as well. The king wears layers of linen so finely spun and woven that it is almost sheer. Colourful borders and a fringe edge his garments, and designs adorn his belt and apron, perhaps worked in tapestry or embroidery. On his head he wears the tall white crown associated with southern (Upper) Egypt, with a ribbon of red cloth trailing behind, and in his left hand he clutches the crook and flail, references to farming and metaphors for the king's care for his people. Around his neck the king—like the three gods—wears a beaded collar known as a *wesekh*, literally a 'broad' collar, which imitates strings of flowers and symbolized renewal.

The deities are just as spectacular, although their clothing sticks to an intentionally old-fashioned look suited to their timelessness. Amun-Re and Khonsu sport feather-patterned corselets, short skirts, and a bejewelled belt with bull's tail hanging behind. Mut's red dress, studded with beads in a net-like pattern, conforms to her body in the way no fabric—before synthetic fibres—possibly could. She holds a slender, papyrus-stem staff, while the male gods hold forked staffs that curve into the snout and ears of a jackal. Their headgear helps identify each deity, but also—like the king's—conveys aspects of their power. Amun-Re's crown rises up into

two colourful tail feathers that pierce the dark blue sky at the top of the scene; he also has a long, narrow beard framing his jawline, often called a 'false beard' by scholars who assume that such beards—when depicted on kings—were taken on and off like a costume. Mut wears a cap shaped like a vulture, its wings falling behind her ears. On top of this sits the so-called double crown, which combines the white crown that Ramses wears with the high-backed, curlicued red crown of northern (Lower) Egypt, referring to the ideal unity of the two regions. The full moon resting on a thin crescent, which sits atop the falcon head of Khonsu, signals this god's association with all the phases of the moon. As with the rest of the gods' clothing, such head adornments in Egyptian art do not necessarily depict actual crowns, any more than the images indicate what people imagined their gods looked like. Instead, art offered a way to represent a god's qualities and the domains over which he or she had special authority.

The contents of the Great Harris Papyrus confirm the immense wealth of the temples, which they used not just to support themselves, but to redistribute through the local economy. Temples were the chief landowners, letting farmers graze animals and grow crops on their behalf. Over the scroll's astonishing length, Ramses IV enumerates the enormous donations he has made to the temple via such landed estates: 309, 950 sacks of grain; tens of thousands of cattle, fish, and geese; dozens of jars of wine and oil, not to mention endless quantities of the dietary staples bread and beer. Trade networks and official expeditions to source minerals, metals, and stones yielded raw materials such as 44,000 bricks of natron salt, while other items were probably made or acquired specifically for the temple: thousands of skirts, scarves, and robes; hundreds of scarabs and pieces of jewellery; and exactly (let's assume someone counted) 155,000 stone beads. The list of riches goes on and on, giving us some idea of what it took to keep a large temple supplied for rituals, as well as the resources it gathered for sale or distribution in the community.

Objects of special significance, like the gold and silver statues and large boat that Ramses had made for the gods, naturally stayed in the temple, but one perk of being a priest was divvying up the leftover food and gifts the gods no longer required. In this way, a temple's largesse reached at least some of the people who lived in its shadow.

Another commodity the temples controlled was knowledge— including the know-how needed for healing, predictions, and prayers. Few people were allowed into the sanctuary itself, but there were other ways of accessing the gods. People could approach certain statues, like those of Amenhotep and Paramessu; seek out the gods in their dreams; or donate objects in chapels built against temple enclosure walls for this purpose. On festival days, priests carried statues of the gods on portable boat shrines, which also functioned as oracles: a 'yes or no' question written on two chits (one for each answer) and placed in its path meant the shrine might dip or sway towards the god's response. Through this method, priests could deal with a number of individual or communal worries, but some matters required more personalized attention—persistent bad luck, family troubles, or ill health. At times of uncertainty and crisis, it paid to believe in magic.

Abracadabra

Today we associate magic with wizards and witchcraft, somewhere between light entertainment and the dark arts of devilry. But in many cultures, including ancient Egypt, magic played a crucial role in everyday religious practices. Priests used some of their ritual knowledge outside the temple, working within the local community to help people predict, interpret, or even influence the will of the gods. Magic frequently overlapped with what we now classify as medical care, so that some priests also tended the sick, as did wise men and women sought out as healers. Regardless of their training and social rank, all these ritual performers had one powerful thing in common: they knew how to use objects,

words, and actions to try to get the best outcome for their clients or patients.

Childbirth—a time of great promise but also grave concern—was one area in which medicine and magic worked together. To give birth, women could squat on clay supports decorated with protective goddesses, combining the magical qualities of these 'birth bricks' with a practical aid for an effective birthing position. A naked, snake-wielding demon might sound like cold comfort in the throes of labour, but in the right hands, an object like the wooden statuette in Figure 14 also helped ward off dangers that might threaten both mother and child. With a body carved from one piece of wood and separate arms attached with dowels, this figure may represent a creature, sometimes known as Beset, who assisted at births. Her naked body was one way to visualize this creature's fearsome aspect, as was her leopard- or lioness-shaped face and the copper-alloy (bronze) serpents inserted through holes in each hand. Traces of yellow and black paint survive on the statuette's face and wig, hinting at its original, more colourful appearance, while re-carving around the feet points to ancient repair or reconfiguring, as if the object had been used over a long period of time.

Beset (if that is the right name) was among a myriad of divine beings that populated Egyptian ritual in less formal contexts than the main temples. Sometimes termed demons or minor gods, these beings never received gold statues, boat shrines, or temple endowments, but they came into their own in rites of protective or predictive magic. Although the wooden statuette with bronze snakes is a unique survival, it resembles other cat-headed, serpent-clutching females that appear on curved wands made of hippopotamus ivory. These were—quite literally—magic wands engraved with all manner of demons, animals, and hieroglyphic symbols; like the wooden statuette, some show signs of use and repair. The ritual performer probably held the wand by one end and used the other, often tapered, end to draw a protected space on the ground or write words and images in sand.

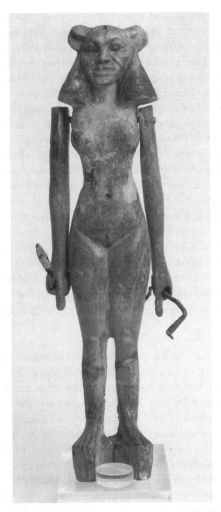

14. Magical statuette of a masked woman, _c._1700 BC. Slim bronze snakes fit into the hands of this wooden figure—a powerful object in the hands of a knowledgeable healer or magician

Four of these wands, and several other magical objects (faience animals, an ivory staff, a twisted bronze snake), were found together with the wooden statuette in a tomb at Thebes dating to the late Middle Kingdom, around 1700 BC. The objects were scattered around a wooden storage box which turned out to contain some of the most significant papyri ever found in Egypt, as well as some 118 thin reeds tied in a bundle, ready to be turned into writing pens. Stashed in a tomb, the contents of the box constitute a well-off and well-educated man's personal library—famous literature and poetry, hymns and temple rituals restricted to male priests, and medical and magical spells that echo the function of the objects found nearby. Some of the texts were written over account ledgers that had been erased, an ancient example of paper recycling. Recent study of all these finds, which are now scattered among several museums, suggests that the papyri and objects alike may have been in one family for several generations before being placed in the tomb of their unnamed owner, either as part of a burial or for safe-keeping. Taken as a whole, they demonstrate that magic was not an obscure practice on the fringes of belief, but an integral part of Egyptian religion and society at every level.

Much as written words and images cannot be separated in Egyptian art, spoken words and objects belong together in Egyptian magic. In fact, the phrase 'abracadabra' derives from the name of the mystical deity Abraxas, invoked in the distinctive mixture of Egyptian, Greek, and ancient Near Eastern magic practised in Roman times. Whether for healing, predicting the future, or righting a perceived wrong, magic involved the specialist performing certain actions on, or with, an object while speaking a particular spell. The magician might 'fix' his or her words in place by tying knots in a strip of linen, which the troubled person then wore; many amulets were probably activated in a similar way, rather than being mere decorative pieces of jewellery. One common practice required either the magician or the client to consume beer or water in which a magical object had

been submerged, or else to pour water over special statues and stelae, then collect and drink it. One such object is known as the Metternich Stela (after its 19th century owner), now in the Metropolitan Museum of Art, New York. Carved from hard, dark stone around 350 BC, it is a large-scale version of smaller stelae and amulets depicting the god Horus as a child, miraculously overcoming the threat of scorpions, crocodiles, and other wild animals. Inscriptions carefully carved into every surface of the stela offer magical formulae against poisonous bites—a metaphor for any illness—and explain that a priest named Esatum had set it up for public use at Heliopolis, a vast temple of the sun god in what is now Cairo.

People in Egypt turned to divine beings like Beset or her male counterpart, the lion-faced, dwarf-bodied Bes, for hundreds of years—even after Christianity became the official religion of the Roman Empire. As the Metternich Stela demonstrates, 'major' gods—especially the moving tales of Isis and her infant son Horus—were also accessible to those in need of spiritual comfort or physical aid. When temple revenues and privileges were scaled back under Roman rule (for fiscal rather than religious reasons), practising magic and healing in their local communities helped Egyptian priests adapt to changing and more straitened times. Works of art and sacred buildings still offered lasting physical links to old gods and older ways, which is one reason they were sometimes targeted by Christian leaders caught up in power struggles both human and divine. Although we should be careful not to conflate the priorities of ancient religion with those of modern, monotheistic religions that emphasize personal accountability and faith, it is striking that all three 'religions of the book'—Judaism, Christianity, Islam—arose in and around Egypt, and were arguably shaped in response to the kinds of rituals, mythologies, and images that had been prevalent for so long.

Gods move in mysterious ways, and power moves with them. Works of art and architecture provided a physical, material way

not only to encounter the divine, but also to organize human relationships in a society that was complex and hierarchical. The architecture of Egyptian temples was designed to keep people out in order to maintain a pure and desirable home for the gods. The scenes and inscriptions that covered a temple's walls and ceilings; the innumerable statues of gods, kings, and priests that filled its rooms and courtyards; and the incredible wealth that poured in through royal gifts, commerce, and endowments, all set temples apart as exclusive institutions, and intentionally so. But far from being cut off from the rest of society, temples were at the heart of it. They were a theatre of operations for the king—a god on earth—and his delegates, the educated, well-born priests who cared for the gods' statues on the king's behalf, helped manage the state's economy, and used their secret, sacred knowledge to influence or appease divine powers when life, or death, demanded it.

Scholars have debated to what extent the average ancient Egyptian could have a personal relationship with any god, given how remote and abstract the expression of religious ideas can seem. Many works of art and architecture tell a different story, however: votive offerings left to seal a pact or make a prayer concrete; magical tools like the wooden statuette and ivory wands, repaired over years of use; and the worn-down laps on the statues of Amenhotep and Paramessu, scanning their scrolls outside one of the largest temple complexes in Egypt. Turning to a higher power was a rational response at times of crisis, which are a fact of human life—and as we'll see in the next chapter, ancient Egyptian artists knew the facts of life quite well.

Chapter 5
Signs, sex, status

Images of kings bashing their enemies over the head, or offering luxury gifts to placidly smiling gods, conveyed a world of royal and divine power by using formal compositions and 'stock' poses whose meaning depended on their clarity of appearance. Ground lines, symmetry, balanced spacing, and symbolic features, such as hieroglyphs or headdresses, allowed Egyptian artists to organize both the known and unknown world, helping to maintain *maat* (cosmic order) in the process. Temple architecture and works of art depicting the king and the gods likewise had to conform to strict standards, which we can think of as a system of decorum—a shared set of unspoken assumptions about what it was appropriate or permissible to represent. At the other end of the scale, more informal objects like ear-adorned tablets left to encourage the gods to hear prayers, or magic wands and figures used by ritual specialists, deployed a different range of images suited to their specific purposes, but no less powerful for that. Both of these extremes—the rigid rules for art relating to the king, and the curious combinations peopling the world of magic—may seem merely functional when we consider them in light of their immediate use, like the magic wands, or their political import, as with temple reliefs of the king. But no work of art can be reduced to a single, fixed meaning, and aesthetic considerations—materials, manufacture, outward appearance—were also integral to the significance, and success, of any building or object.

Many of the visual themes that appear in ancient Egyptian art and architecture are part of a rich symbolic system that refers to abstract concepts, idealized landscapes, religious ritual, or the vocabulary of hieroglyphic writing. This can make many of the works seem repetitive or mannered: why fill each temple with near-identical doorways, columns, and carvings, and didn't anyone care that coffins looked an awful lot alike? To some extent, however, that sense of sameness was desirable. For the highest levels of Egyptian society, who had a vested interest in keeping things the same (or at least pretending to), visual consistency emphasized continuity with the past, which lent their actions the authority of age. At the same time, innovations in building and material technologies, content choices, and style allowed ample scope for artistic creativity—and for doing things distinctively. Some eras, such as the Old Kingdom, favoured restraint and simplicity in art, while others, such as the late New Kingdom, embraced ornamentation and busy effects. Ancient audiences recognized such differences, and many more besides.

Viewers today have to work a little harder to make sense of an ancient Egyptian statue, wall painting, or building in order to identify not just its date or function, but the wider array of meanings it held. Recognizing some key features enables a better understanding of what significance a work had in antiquity, and why it was designed to look the way it does. Protective signs or identifying hieroglyphs, colour symbolism, and hidden references—such as in-jokes and sexual innuendoes—help open up the world of Egyptian art beyond its calm outward appearance. The human dimension of procreation and birth, bookended by the inevitability of death, makes our encounters with these works more immediate, even intimate. We can never step into an ancient Egyptian's shoes (or papyrus sandals), but trying to is its own challenge and reward.

Imagery related to fertility and sexuality may strike modern viewers as delightful, shocking, or both, but it offers an important insight into Egyptian society. As in other pre-industrial societies,

life in ancient Egypt entailed close interaction with the natural world, including its flora and fauna; the climate and landscape; the movement of sun, moon, and stars; and inevitably the course and annual flooding of the Nile. The human lifecycle belonged to the same environment, subject to the forces of nature even as humans set about controlling, charting, and recording them. Through the materials they used and the objects they made, ancient Egyptian artists and craftsmen turned animals, plants, and the Nile itself into metaphors for what cannot be seen—good and evil, the moment of creation, or the transformation of the dead, all of which we will consider in this chapter. If its themes and motifs make Egyptian art and architecture seem stuck in the mud, at least it was the best mud possible: the Nile's.

Living in the natural world

Museum gift shops do a nice line in blue hippos: key rings, t-shirts, cuddly toys, even Christmas tree ornaments. Pleasingly plump and brightly coloured, these faience animal figures have become mascots for several Egyptian collections. Since the 1930s, the Metropolitan Museum in New York has referred to an example in its collection as 'William', after a humorous account in the London magazine *Punch* by an Englishman named Captain H. M. Raleigh. A framed print of the Metropolitan Museum hippo hung in Captain Raleigh's drawing room, leading the Raleigh family to name the hippo William and treat it—or him, as they would say—like a member of the family. To the Raleighs, William was 'inscrutable, incomprehensible, and yet with it all the friendliest thing in the world'. They took to consulting the print—that is, the hippo—for family decisions, to all intents using William like an ancient Egyptian oracle. Was William looking gloomy or pleased, worried or calm? The results of, for example, Mrs Raleigh's bridge game hung in the balance.

In ancient Egypt, hippopotamus figures like 'William' were not concerned with card games, but they did combine two demeanours,

beastly on the one hand and beneficial on the other. Although hippopotami retreated to the southern reaches of the Nile valley over time, the threat they posed remained in cultural memory: the sheer bulk of the hippopotamus (adults weigh more than 4,000 kilograms (kg)), and the female's aggression when her calf is threatened, made the hippo a danger to sailing vessels, people working along the river's edge, and crop fields, which hippos graze and trample. In Egyptian art, the hippo could represent Seth, the disruptive god who killed his brother Osiris and wrongfully seized the throne from Horus. From the Old Kingdom to the Ptolemaic Period, hunting scenes showed Horus, the king, or intrepid boatmen spearing hippos to vanquish evil. The hippo also had more benevolent associations, through the hippo-bodied, crocodile-tailed goddess Taweret who, like Bes and Beset, assisted women in childbirth.

Around 50 faience figures of hippopotami survive, several of which archaeologists found in tombs dating to 12th, 13th, and 17th Dynasties (c.1900–1700 BC; despite the numbering, these dynasties were consecutive in much of Egypt). Like an example in Vienna (Figure 15), many of the figures had at least one leg broken off, ritually crippling them. The museum in Vienna has restored the animal's front right leg to help the figure stand upright. This intentional damage offers a clue to how, and why, the faience hippos were placed in burials, since it enabled the ritual performer to quash the animal's power to cause harm. The acts of mixing the faience paste, moulding it into a hippopotamus form, and firing it likewise allowed human ingenuity to overpower a wild beast, cutting it—almost literally—down to size. The bright blue or blue-green colour of the copper-based glaze evoked more precious materials such as turquoise and lapis lazuli, as well as the natural colours of the sky and the river. Most striking of all are the black outlines drawn on before firing. In addition to delineating the hippo's eyes and facial contours, the line drawings pattern its body with water lilies and their curving leaves. A lily in full

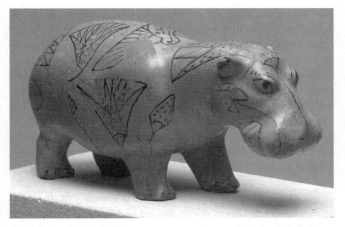

15. Faience figure of a hippopotamus, _c._1700 BC. The front right leg of this faience hippopotamus has been replaced in modern times, because the original was broken off when the figure was placed in a tomb

bloom spreads over each side, up from the hind end, and across the back of the neck, met by a duck in flight. It's as if the hippo has merged with the river marshlands which were its habitat—and since the Nile was the source of life, and the marshes a place that teemed with it, the hippopotamus figure came to embody life-giving properties, its strength and power made to work for, rather than against, the tomb owner.

References to the marshes recur throughout Egyptian literature, art, and architecture. Papyrus and other reeds flourished in the Delta and the flood plains of the river valley. These plants had multiple uses—not only to make writing materials, but also for ropes, baskets, boats, and buildings, since stone was used only for high-prestige buildings such as temples and tombs. Our impression of the built environment in ancient Egypt is skewed because few mud-and-reed or mud-brick structures survive.

However, stone masonry often mimicked buildings made of less durable materials like reeds and mud, as if architects were rendering nature more permanent. Bundles of tall reeds thickly plastered with mud made effective enclosure walls, and the flopping reed fronds left free at the top of the wall inspired the flared cavetto cornice so typical of Egyptian architecture. Walls built in this way, or of the other common building material, sun-baked mud brick, worked best if they were battered, that is, wider at the bottom and tapering to the top—another form used for stone architecture, especially temple gateways like the pylon at Dendur (see Figure 6 in Chapter 2). The corners of walls and the edges of doorways, where the circular stems of bound reeds offered reinforcement in mud-based buildings, were laboriously rendered with curved edges in their stone equivalents.

Temple complexes used both mud and stone architecture to impressive effect. Mud-brick walls laid in uneven rows encircled the temple precinct, their wave-like structure recalling the watery, chaotic ocean out of which the natural world was born. The temple sanctuary stood as if on the higher ground that emerged as the Nile flood receded, just as the riverbanks sprang back to life each year. The flood plains in which most ancient Egyptians lived and worked informed the most striking aspects of temple architecture from the New Kingdom onwards. The columns supporting high-ceilinged halls and open courtyards resembled bundles of palm fronds, lily stems, or papyrus plants, with corresponding capitals. Alternating papyrus heads and water lilies symbolized the southern and northern regions of Egypt as well. Given the importance of the Nile and its marshes, it's no wonder the water lilies, reed plants, and fish, birds, and insects that thrived in this environment offered such a source of inspiration to architects and artists. The marshes were fixed in the Egyptian cultural mindset as the place where life began—and where there was good (though not always clean) fun to be had.

In the marshes

During the 18th Dynasty (c.1550–1350 BC), a period when Egypt enjoyed advantageous trade relations with its neighbours, the well-to-do men who held positions in the state administration built richly decorated tombs comprising a burial chamber, to be sealed off from visitors; an inner chapel where statues of the dead received offerings; and an outdoor courtyard that played host to lavish banquets on holidays to remember the dead. Some of the most famous paintings in ancient Egyptian art derive from the confined space of these tomb chapels, which consisted of an entrance corridor and one or two narrow rooms, culminating in the statue shrine at the back. In contrast to these narrow, sunless spaces, however, the paintings themselves depict a vivid world in which the tomb owner and dozens of his family members, friends, and servants appear to be drinking, listening to music, and enjoying sporty excursions on the Nile. Is this the Egyptian leisure class at play? Or is there more here than meets the eye, once we know how to recognize the signs?

One of the best-known examples of these chapel paintings comes from the tomb of Menna, a scribe responsible for monitoring agricultural production around ancient Thebes, including farm estates that belonged to the temple of Amun. The middle of the right-hand wall (as a visitor approached the statue shrine in the rear chapel) was filled almost top to bottom by a colourful painting of Menna hunting birds and fishing from a reed raft (Figure 16). The painting shows Menna in an almost-mirror image, facing himself across a papyrus thicket in the middle of the scene. The marshy stream beneath and between the rafts is rippled blue and teems with life: blue water lilies and ducks; Nile perch and mullet; and a miniature crocodile about to chomp on a tilapia, the same species of prize fish the right-hand figure of Menna tries to spear with his harpoon. On the left-hand side, Menna adopts a similar stance—body lunging forward, rear arm raised—to hunt ducks and

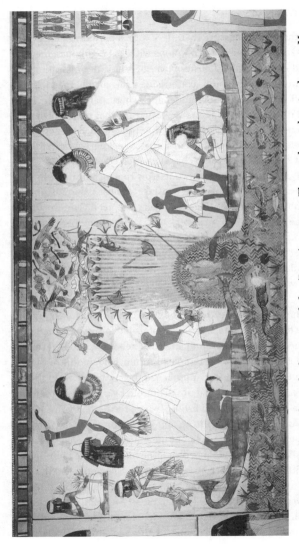

16. Fishing and fowling in the tomb of Menna at Thebes (Luxor), c.1450 BC. The marshes—where tomb owner Menna and his family seem to have ventured—evoked ideas of pleasure, sensuality, and rebirth

other waterfowl, which fly up from the marsh, their bodies crossed by the boomerang-like throw sticks used to knock them down.

The posture Menna adopts should seem familiar from an object we considered in the previous chapter—the ivory sandal tag of king Den smiting an enemy from the east (see Figure 12 in Chapter 4). No one other than the king could be shown in the role of smiting enemies, but echoing the posture in the 'fishing and fowling' scene (which is how Egyptologists refer to compositions like the Menna painting) allowed the tomb owner to accomplish the same thing on a more personal scale. Hunting was a metaphor for imposing order on unruly nature and overcoming adverse circumstances, including the ultimate adverse circumstance— death. All of Egypt benefited from the king's smiting action, while in tomb paintings, the benefits of fishing and fowling accrued to Menna and the people shown around him: his wife Henutawi and their sons and daughters.

Looking carefully at the scene confirms that this is more than just a family taking recreation on the water. Crouching on the left-hand raft, for instance, is a naked girl, her lack of clothing a sign that she is either the youngest of Menna's daughters or a servant, since nudity was a convention for representing small children and low-status female servants and entertainers. Because Menna's tomb paintings were never finished, there are no hieroglyphic texts to identify her. This figure is playful but suggestive too: her hips and arms are lavish with jewellery and her nipple erect as she grasps the stem of a lily with both hands beneath its tightly closed bud, trying to pull it out of the river. Knocking down waterfowl and spearing fish were not the only ways to conquer death, metaphorically speaking. Enjoying the pleasures of the natural world, and having friends and family to keep your memory alive, helped too—so did sex.

Although the girl's nudity may be the only feature of the painting that strikes modern viewers as risqué, to ancient viewers, the scene

heaved with sexual innuendo and imagery familiar from love poetry of the time. Believe it or not, tilapia fish were associated with sex and procreation: the tilapia's method of incubating its eggs in its mouth, then expelling the young, paralleled an Egyptian creation myth in which the god Atum either spat out saliva or ejaculated in order to create humans from his own bodily liquids. In the New Kingdom, striped glass bottles in the shape of a tilapia were prestigious containers for perfume, and sweet scents were signs of the gods. Collecting, wearing, and smelling blue water lilies had erotic overtones, which is why all the women in the scene are wearing and holding them; the Egyptian words for 'scent' and 'ejaculation' sounded similar, making this a visual and verbal pun as well. The lily leaves and roots had an intoxicating effect if—as some research has suggested—they were pulped and added to wine, enhancing or encouraging romantic liaisons. In the right-hand raft, the affectionate gestures whereby Henutawi and the kneeling woman (most likely an older daughter) wrap their hands around Menna's body refer to sexual relations, too. The sport here is less to do with catching fish and fowl, than with catching a mate in order to make love—and babies.

'Going to the marshes', then, was a pleasurable activity with specific cultural associations. The papyrus thickets along the river banks and in the flood plains, so full of plant and animal life, were places of carefree abandon in the imagination of the Egyptian elite. Alongside the marsh scenes of fishing and fowling, 18th Dynasty tomb chapels also included opulent banquet scenes, complete with musicians, scantily clad dancers, and blind harpists whose songs lament the brevity of life. Male and female guests often appear in different registers, draped with lilies, tended by nubile maids, and plied with alcoholic drinks. In some banquet scenes, female guests inhale the rich scent of ripe mandrake fruit, recalling Egyptian poetry in which the smell of mandrake reduces sexual inhibitions; the fruit itself, when mixed with wine, induced dream-filled sleep if all else failed. What the tomb paintings represent is less an actual dinner party than a festival of

drunkenness—not unlike the regular feast held in honour of Hathor, a goddess identified with beauty, love, the marshes, and the dead. No wonder Hathor was known as 'the Lady of Drunkenness'.

The banquet scenes are not entirely a figment of artistic imagination. Funeral meals did take place in the outer courtyards of tombs like Menna's, probably at the time of the burial and on special feast days thereafter. Hospitality on this scale fostered social cohesion among the survivors, as well as reinforcing the status of the tomb owner and his family. Such banquets also provided an opportunity to visit the painted chapels, whose small size ensured this would be an intimate experience undertaken in small groups. The quality of the paintings demonstrated the tomb owner's access to skilled artists—Menna's paintings are especially innovative in their layering of colours—and their visual impact was not lost on visitors, who sometimes left appreciative graffiti behind. Visitors could pick out fine, often humorous, details in the paintings—a cat trying to steal bird eggs, captions poking fun at clumsy workers—as well as savouring the ribald allusions. Pleasurable as it was, viewing the chapels inevitably juxtaposed the world of representation with the reality of life. The painted marshes and idealized rural landscapes were far away, in every sense, from the desert edge where the tomb chapels stood—a contrast as stark as the harpist's sad songs, with their warning that death was the end.

Death and rebirth

The blind singer's laments challenge the assumption made in so many museum displays, books and websites, and television documentaries—that the Egyptians believed fervently in a life after death where the pleasures of this world would continue. In their ancient settings, the songs were subtly subversive, but in a safe and knowing way. Otherwise, they would not have featured in chapels so close to the burial chamber that held the owner's carefully prepared

mummy and tomb equipment. The songs gave a philosophical wink to the uncertainty of life's end, and were all the more reason to enjoy the wine, music, and food on offer at feast days.

In a society as complex, long-lasting, and geographically extended as ancient Egypt, we shouldn't expect there to be a single idea about what happened to the dead, either as a formal theology or among the wider population. Much of our evidence—from the collection of magic invocations known as the *Book of the Dead*, to tomb chapels and funeral stelae like Irtysen's (see Figure 8 in Chapter 3), to grave goods, mummies, and coffins—derives from an elite context, and frequently a male one at that. How the Egyptian poor were buried, no one knows; the simplicity of their burials means that archaeology may never recover them. At sites where systematic excavation techniques have been more careful about recording every scrap of evidence, there are suggestions that cemeteries did fill up with enough bodies to represent much of the local population—but over what period of time did this occur, and did different burial methods depend solely on cost implications or on more elusive criteria, such as the social position of the deceased?

The oft-repeated idea that mummification was necessary to preserve the body for the afterlife is a simplification. In fact, applying natron salt (with its cleansing, drying effect), resin (used as temple incense), and linen (linked to healing and rebirth) was a way to treat the dead bodies of high-status individuals as if they were sacred objects, like the statues of gods carefully tended in temples. The preservative quality of these materials, especially after the body's organs had been removed, may have been a secondary effect which developed over time as part of an increasingly elaborate, specialized procedure used when certain people died. As a method of caring for and burying the dead, mummification also encouraged a host of other creative efforts, yielding art works, architectural structures, and performances that accompanied the wrapped mummy to the grave.

Individuals buried in this way expressed a desire to be reborn into a new, transfigured existence in the afterlife, which ancient Egyptian termed *akh*, a 'glorified' or 'luminous' spirit. Several myths offered ways to represent this transformative process, and many of the images on coffins or inside tombs marshal these myths on behalf of the dead. The sun god Re followed a human life cycle, born at dawn and ageing through the day until his death at sunset. Overnight, he was reborn in the body of the sky-goddess Nut, who often appears on the inside of coffin lids, or on the ceilings of temples and tombs, her body speckled with stars. The night was also the underworld, or *duat*, a place of potential hazards. Like humans, the sun god needed magical protection too, and Egyptian art used many visual devices—amulets, doorways, fantastical creatures—to provide it.

A parallel mythology revolved around the murdered god Osiris, his sister–wife Isis, and their son Horus, conceived after Osiris died. In art from the New Kingdom onwards, symbols and scenes linked Osiris, the mummy, night-time, and the underworld on the one hand, with Re, the spirit-soul, daytime, and the heavens on the other. What both gods had in common was the need for rebirth, which only a woman's body could accomplish: Nut for the sun god and Isis for Osiris. The close connection between death and rebirth fuels the sexual references in Egyptian art. Near-naked goddesses, gods with erections, and cults for virile animals, like bulls, make sense in religious imagery because they captured the miracle of life creating new life.

Her life-giving powers made Isis the greatest of all Egyptian goddesses, whose worship spread from the Nile valley throughout the Middle East, North Africa, and Europe. Isis was popular among soldiers in the Roman army, and images of Isis nursing Horus probably influenced representations of the Virgin Mary and infant Christ in Byzantine Christianity. A bronze statue dating to the 25th Dynasty (*c*.600 BC), made in three or four pieces—each figure and the throne on which the goddess sits—shows Isis

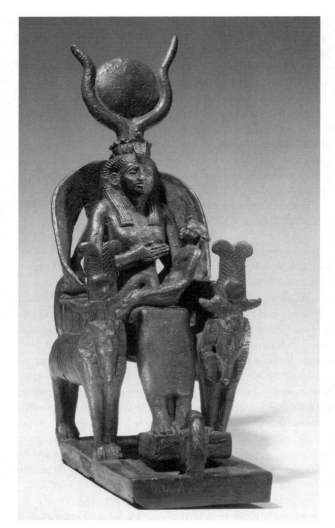

17. Bronze statuette of Isis nursing Horus, c.600 BC. Isis sheltered her son Horus from danger throughout his childhood, in a set of myths that helped make her the most powerful, and popular, of Egyptian goddesses

guiding her breast towards Horus, whom she supports on her lap (Figure 17). When shown as a child (as on the Metternich Stela), Horus always took human form, rather than the falcon-headed form of his adulthood. Isis wears regalia fitting her twin roles as queen to the dead Osiris and as a goddess: over her long hair sits a feathered cap, a large cobra fronts her brow, and on her head are a ring of further cobras topped by the horns of a cow, with the sun disk cradled between them. The curved-back throne supported on two standing sphinxes adds to the resplendent presentation of mother and child. The tall feathered headdresses the sphinxes wear, supported on ram horns, signal divine light and regeneration: the same crown appeared on the god Andjety, one of many manifestations of Osiris.

By using her knowledge of magic—she was known as 'the Great Lady of Magic'—Isis successfully conceived, bore, and raised her son in secret, hiding him on a marshy island until he was old enough to avenge his father's murder and reclaim the throne. It was this cycle of stories, based on the difficulties she had to face, that made Isis the goddess to whom so many turned for succour and strength. Childbirth and child-rearing were not exclusively female concerns, but were embedded in everyday religious ideas and forms of high culture, like the bronze Isis. This statue is one of thousands dedicated at temples by people of means who sought the goddess's favour or wished to give thanks. An inscription in hieratic script on the front of the plinth identifies the man who dedicated the statue as Khonsu-pa-shered, and he too appears as the small kneeling figure in front of Isis's feet (with his back to us in the photograph), dressed for his role as a priest. The contrast in scale used to denote status difference in paintings and reliefs worked for images in the round as well.

The bronze Isis with her child, enthroned in glory, testifies to the artistic output of Egyptian temples and their workshops—and to the importance of images for making tangible and visible the abstract world of light, air, and myth, of the gods and the dead. But

as we've seen elsewhere in this chapter, and throughout this book, only select individuals could deploy this artistic output. In art, a goddess like Isis always dwarfed a human like Khonsu-pa-shered, but the very fact that he could dedicate this bronze suggests that on the social scale of his community, Khonsu-pa-shered loomed relatively large.

The privileged few

Around two thousand years before Khonsu-pa-shered dedicated the statue of Isis and Horus, a man named Hesy-re was in charge of the royal scribes under king Djoser (*c.*2630 BC). This post earned him a large tomb not far from Djoser's Step Pyramid at Saqqara, just a few generations earlier than the more familiar, straight-sided pyramids at Giza. Looking at this earlier period of Egyptian art and architecture, and how it was shaped by a narrow segment of society, lets us see where many of the cultural ideals in later art derived their underlying values. It also helps us review several of the ideas we've considered in this and previous chapters: the emphasis Egyptian art and architecture placed on orderly design; the signs and symbols incorporated into images, which were fundamental to their uses and meanings; and the ways in which buildings and works of art led social lives, bringing together the king, the elites (priests and officials), and menial workers (farmers, craftspeople, labourers) while at the same time reinforcing the differences between them.

At this period, kings granted leading officials like Hesy-re burial places near the royal tomb, with the result that Saqqara, Giza, and similar sites mapped the structure of elite society onto the pyramid field and its satellite cemeteries. Those closest to the king were buried closest to the pyramid in so-called *mastabas*—an Arabic word for a low bench, adopted by 19th century Egyptologists for these flat-topped, slant-sided, rectangular tomb structures. Early *mastabas* were almost solid, built of mud brick and pierced by shafts that led to underground burial chambers.

Outside against the long, east wall were altars where priests and visitors could leave offerings before a stela representing the deceased. In some *mastabas*, the offering places became part of a sheltered chapel or—in the case of Hesy-re—an inner room, perhaps created when the tomb was remodelled and extended during his long career.

It was in this inner room, just over a metre wide, that an Egyptian archaeologist named Osman Duqmaq recalled locating five remarkable panels of Hesy-re (two of which appear in Figure 18). In 1862, Duqmaq was working as a basket boy for French Egyptologist Auguste Mariette, whom Said Pasha, the governor of Egypt, had hired to establish a government antiquities service and museum. Mariette's report said little about the discovery of the panels, or even the location of the tomb, but almost fifty years later, Duqmaq identified the spot for James Quibell, a British archaeologist who cleared sand and debris from the *mastaba* and re-excavated the long, narrow chapel. In the process, he found a sixth panel still in place at the far end, the last in a series of eleven niches built into what may have been the original east wall of the *mastaba*. The niches gave the wall a stepped profile, with brickwork imitating the texture of woven mats—like the enclosure around early royal names (see Figure 12 in previous chapter). As a feature shared by royal and non-royal architecture, and used for hieroglyphic writing and other art forms, this motif helped connect the king and the people who occupied the rarified world of the Egyptian state.

Each of the surviving acacia-wood panels shows Hesy-re in a different pose, hairstyle, and dress. Subtle differences suggest they may have been made by different artists, perhaps at different times; the original paint that would complete and enliven them is long gone. Each panel is 1.15 m high and ended not far off the floor, meaning they were low down in relation to viewers. The cut-out notch at the top of each panel may have helped fix it in place, or else held an attachment of some kind. In the recessed field that covers the lower three-quarters of each panel, the

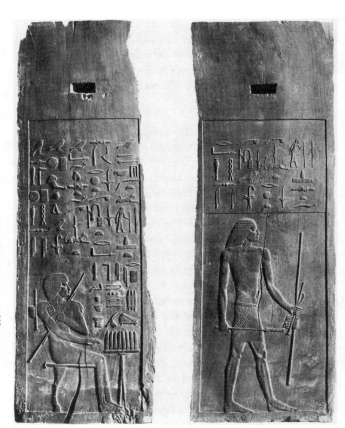

18. Wooden reliefs of Hesy-re, _c._2600 BC. The tomb of high-ranking official Hesy-re had a chapel lined with several of these wooden panels, which have lost their vivid paint

sculptor removed the background to execute the inscriptions and figures of Hesy-re in subtly modelled relief. In keeping with conventions, each figure faces right. On most of the panels, Hesy-re stands left leg forward, holding or carrying signs of his rank (walking sticks and staves) or abilities (the scribe's writing kit

over his shoulder). His slender body has well-defined bones and muscles, and his chiselled cheeks bear just enough signs of age to seem wise. The panels may be a chance survival, but it isn't hard to imagine that they, and their chapel, were a unique creation for a man who had served the king well and earned a fine burial for himself and his own dependents.

Unlike the later paintings from the tomb of Menna, the decoration of Hesy-re's chapel focuses exclusively on him, although other members of his family and household may have benefited by association. The panel on the left side of Figure 18 was probably opposite the chapel entrance, making it the first one a visitor saw. It shows Hesy-re in a pose that Egyptian art would revisit for millennia: he is seated at a table piled with bread, facing a hieroglyphic prayer that grants him beer, meat, linen, and jars of perfume as well. Hesy-re wears a long robe, which would have been painted with leopard spots, and reaches one hand out towards the offering table.

Turning to the right, visitors to the chapel would then see the patterned brick niches stretching down the same wall, set with the other ten panels. Each of the salvaged panels shows Hesy-re standing, as if he could stride towards the offerings at the far end of the room. The long wall opposite the panels had no niches, just a flat surface painted with some of the fanciest products of the day, arranged in orderly rows and headed by a long list: board games, furniture, weapons, headrests for sleeping on, and every imaginable size and shape of stone vase, bowl, and table (compare the earlier examples in Figure 10 in Chapter 3). We could imagine that these represent items Hesy-re wished to have in the next life, and that painting them magically made them available to him forever. However, two considerations are more important for our own insight into ancient Egypt. First, these were the products valued, circulated, used, and, indeed, tallied up and represented among the top ranks of Egyptian society. Second, such a stratified society needed everyone to feel part of a greater whole: someone

had to make the mud bricks, drill the stone vases, and bake the bread. Egyptian art and architecture was created by the many for the enjoyment of the few—yet when we admire the beautiful carvings of Hesy-re, we can look beyond him alone to remember all those names and faces that history never recorded.

The austere look of the Hesy-re panels, emphasized by their lost paint, may seem a stark contrast to the eroticism and luxury of Menna's chapel, the elaborate bronze Isis, or the bright blue hippos that have launched a thousand postcards. But each in its own way met a need that had as much to do with social status as with magic or myth. The examples we've considered in this chapter indicate how much elite men dominated the world of high culture, from art and entertainment to religion and the running of the state. Women were an integral part of this social stratum as well, but gender roles and family relationships informed who was represented in art, and how. This applied to both the human and divine realms, since many myths were structured around gods characterized as husbands and wives, brothers and sisters, or parents and children. Distinctive as Egyptian art and architecture were—with their hieroglyphic symbols, compositional rules, and social strictures—they also tapped into familiar concepts and concerns that have spoken to people well beyond the borders of Egypt and across time. 'William' the hippo had an afterlife his ancient makers could never have imagined.

Chapter 6
Out of Egypt

The long afterlife of Egyptian art and architecture extends from antiquity to the present day. As we saw in the first chapter of this book, 'when' and 'where' ancient Egypt is, or was, in some ways marks an arbitrary distinction. Egyptologists have sometimes been uncertain how to grapple with visual material that doesn't slot neatly into our own categories—Egyptian, Near Eastern, or Greek, for instance. But people moved in and out of Egypt all the time, and material culture moved with them. Egyptian-themed objects circulated around the ancient Mediterranean, Middle East, and Africa. By the time the bronze Isis and Horus was cast, around 600 BC (see Figure 17 in Chapter 5), Egypt was part of a militarized yet metropolitan world, interconnected from the kingdom of Kush (later Meroë) in Sudan, to Assyria in Iraq, to the Greek-speaking world of the Greek mainland and islands, and Turkish coast. When Alexander the Great annexed Egypt in 332 BC, passing through on his military campaign against Persia (Iran), he knew what to expect because Greek authors like Herodotus had written about their exploits there. Aspects of earlier Greek culture (including art) were indebted to its engagement with Egypt through trade, while an influx of Greek immigrants after Alexander brought new forms of government, religion, and art and architecture to Egypt itself. Eventually, the incorporation of Egypt in the Roman empire meant that Egyptian

art became both part of the classical heritage, and a sign of something 'other' in Roman culture.

Although Christianity and Islam rejected most of the art forms associated with the ancient religion, both the Hebrew Bible and the Koran refer to the wisdom and might of pharaonic Egypt, exemplified by the battle over magic that Moses and Aaron wage with Egyptian priests. In medieval Cairo, scholars pored over hieroglyphs and measured the pyramids, while in Europe, before and during the Renaissance, Egypt presented a conundrum: it stood for the despotic power of the Old Testament pharaoh, but it was also home to wise men like the mystic Hermes Trismegistos ('the thrice-great', derived from the god Thoth). Did ancient Egypt deserve admiration, or condemnation—and was it the source of Greek culture, as writers like Herodotus had said, or was it part of darkest Africa or the exotic Orient (as later European thinking went) and thus nothing to do with 'us' at all?

This chapter considers how other cultures have engaged with ancient Egyptian art and architecture at different times and in different places, including Egypt itself. First, we'll look at changes—and revivals—in art and architecture as people in Egypt adapted first to Greek and later to Roman rule. Even before Augustus added Egypt to the Roman empire, Romans had been fascinated by Egyptian religion, incorporating Egypt-inspired themes in their homes and public buildings. For a long time, the classical world's interpretation of ancient Egyptian art, taken together with accounts by Herodotus and other ancient travellers, was almost all that Europeans knew about Egypt apart from the Bible. That changed in 1798, when Napoleon—then an ambitious young general—invaded Egypt accompanied by an auxiliary of scientists and scholars who set about recording ancient monuments and modern life. Although Napoleon was routed by British and Ottoman Turkish forces, his efforts marked the start of a new relationship between Egypt and the West.

Since the 19th century, many interest groups have referred to Egyptian art and architecture to link themselves with the accomplishments of ancient Egypt—often to claim values of permanence and endurance or to exert political influence over Egypt as a modern state. The duality that seems to have been at work in Roman ideas about Egypt—that it was strange and different, but also an important cultural forebear—became even more pronounced in the colonial era and its aftermath. Which groups, and what works of art and architecture, belong 'in' or 'out' of ancient Egypt? However misguided the question may seem, it continues to shape the study of Egyptian art and its role in the contemporary world.

Aegypto capta

When Augustus commissioned small temples like Dendur (see Figure 6 in Chapter 2) to mark his rule as 'pharaoh' on the contested border between Egypt and Meroë, he must have been smiling, if only on the inside. Egypt was the icing on the proverbial cake that Rome had been making for decades, as it extended its financial influence and military control far beyond Italy. Ruled by a dynasty of Macedonian Greeks (the Ptolemies), Egypt was the last holdout of the so-called Hellenistic kingdoms established by Alexander's friends and heirs. With the defeat of Cleopatra, who killed herself to avoid capture, the Romans took control of a venerable and wealthy country. Egyptian grain exports fed the city of Rome, and its papyrus kept the imperial bureaucracy in office paper. No wonder Augustus issued coins commemorating the victory, with a chained crocodile on one side and the motto *Aegypto capta* ('Egypt has been taken').

During 300 years of Greek rule, the society and economy of Egypt changed considerably. A new capital at Alexandria became the most cosmopolitan city in the Mediterranean, its architecture based on classical forms but with Egyptian-style monuments as well. The

first Ptolemies sought support from the Egyptian elite and funded some of the largest, most elaborate temples ever built for the Egyptian gods. Although Greek speakers who settled in Egypt brought some of their own social institutions with them, they also married into Egyptian families and worshipped local gods; the Ptolemies designed a new deity, named Serapis (and married to Isis), to appeal to the newcomers too. The visual arts flourished in such a dynamic environment, which they helped shape as well, fostering new styles that embraced naturalistic Greek images, revisited and expanded Egyptian art forms, or yielded subtle combinations of the two. By the time Augustus set foot in Egypt, it seems the Romans had difficulty telling who was Greek and who was Egyptian, because many of the differences had long ago eroded.

The Roman administration imposed categories to formalize membership of the top ranks of society in Egyptian cities and towns—and give them tax breaks. But people found their own ways to classify themselves too, especially when it came to questions of privilege and prestige among their local communities. Burials—which had always been a favoured area for display in Egypt, as we've seen—offered a perfect opportunity to highlight the social standing of certain individuals or families, no matter what their 'official' status was. All over the country, artists explored new ways to decorate tombs, coffins, and mummies, whether using fancy Greek techniques to paint portraits for mummies, or reviving old-school Egyptian images and hieroglyphic hymns. The results were so weird and wonderful that when Egyptologists first encountered them, they wondered which department, or even which museum, to put them in.

The mummy mask in Figure 19 shows how artists in Roman Egypt reconfigured a fundamentally Egyptian type of object to serve the needs of people who were a rung or two down the social ladder from the highest ranks. These individuals, living in provincial towns, had no influence on a country-wide scale and were excluded from the most privileged categories under Roman

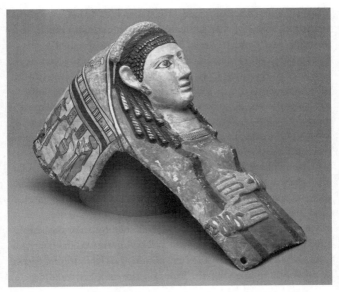

19. **Mummy mask for a woman, 2nd century AD. When Egypt was part of the Roman empire, the leading families of local towns often commissioned elaborate masks or painted portraits for the mummified dead**

law. In their burials, though, they could marshal resources to distinguish themselves through the performance of age-old rituals and the creation of striking works of art. Like many masks that come from Middle Egypt, this mask was made by shaping plaster over a mould, with a layer of linen stretched over the surface to provide support for the final layers of plaster and paint. On the reverse of the mask, the mould left a deep indentation for the face, and smaller ones for the breasts. The curved sides were designed to cradle the head end of the wrapped mummy, and holes in the bottom edge of the front helped tie the mask in place.

The sculptural effect of the plaster may seem life-like, but as with the mask of Tutankhamun (see Figure 3 in Chapter 1), this mask

was probably more concerned with showing the dead woman transformed after death, rather than her actual appearance. To do this, the mask combines 'real life' features with spiritual ones. The dark red dress with thick purple stripes down the front is typical of the clothing worn in the eastern Mediterranean at this time, around AD 100. Examples of the twisted snake bracelets and looped earrings survive from Roman times, but since most mummy masks for women at this period show the snake bracelets, it's difficult to say whether every woman really had a pair, or if the bracelets on the mask signalled protection or something about the woman's life, such as her marital state. Like the bracelets, the fringe of tight curls over the woman's forehead, with long, spiralling curls along her neck, is realistic enough, but we can't rule out other meanings it may have had. For instances, goddesses like Isis were renowned for their beautiful hair, which classical-inspired art in Egypt preferred to show as layers of corkscrew twists. Other mummy masks faithfully copied hairstyles popularized by the Roman empresses instead.

Her pale, gleaming skin colour and the pink wreath of flowers on her head make it clear that the woman on the mask has transcended death—and the mask itself, together with the mummification, wrapping, and funeral rites, helped her do it. The sides and back of the mask use imagery indebted to the wall decoration of Egyptian temples, further linking the deceased to the gods. Pairs of mummy-shaped figures on either side of the mask are gods known as the Four Sons of Horus, in earlier periods identified with jars that held a mummy's internal organs. Here, they refer to the divinity of the embalmed body, while the ewer in between them held Nile water, essential for the rituals that would sustain the dead woman. At the very back of the mask (not visible in the photograph), she herself appears like the falcon of Horus, triumphantly reborn in the heavens.

Although we have no record of this woman's name, age at death, or her family, similar burials from this part of Egypt were for

people with both Greek and Egyptian names, reminding us that this was a culture where people could be as comfortable reading the *Iliad* as they were attending festivals for the Egyptian gods (who themselves often acquired Greek names). On the one hand, people in Roman Egypt used an older artistic lineage to promote themselves in their communities; on the other, they embraced new visual techniques and technologies (like the synthetic pink and red pigments on the plaster mask) to create works perfectly suited to the hybrid society that Egypt had become—a society that seems to have been confident in itself even if it remained a mystery to Rome.

Flights of fancy

In Roman Italy, Egypt had been a source of artistic inspiration even before it became part of the empire. Travellers' tales described it as a place of wonders and the source of the Nile as the ultimate mystery, lying beyond known territory. Around 100 BC in the town of Palestrina near Rome, a mosaic floor laid inside a temple grotto showed the Nile in flood, meandering through Egypt from the Ethiopian hills towards the Mediterranean coast, past sailing skiffs and rowing boats, hippos and crocodiles, and temples in both classical and Egyptian styles. Although made for a sacred space, where dripping water could trickle over its surface, the mosaic suggests that Roman viewers saw Egypt as a bit of fun, an exotic playscape worlds apart from their own culture. But there was a serious side to Roman opinions of Egypt as well. Once Egypt was no longer a foreign kingdom, but under Roman power, Augustus wasted no time in having a red granite obelisk shipped from Egypt to Rome—a feat in itself—to be the centre of a giant sun-clock near his personal tomb. This undertaking demonstrated imperial power, but it also acknowledged shared Roman and Egyptian interest in the sun as a symbol of divine rule. Egyptian religion—especially the worship of Isis—was popular throughout the Greek and Roman world, with Italy alone boasting several Isis temples.

The far-flung Roman empire was reasonably well connected, and although few Roman citizens settled in Egypt longer term, many people travelled on business or with the army. The emperor Hadrian and his wife Sabina visited Egypt with an entourage that included the poet Julia Balbilla, who wrote an ode to the colossal statue of Amenhotep III at Thebes, thought to 'sing' at dawn as dew evaporated from its ancient cracks. Also travelling with them was a young man named Antinous, who hailed from Turkey and was a favourite companion, perhaps a lover, of Hadrian. Tragedy struck in AD 130 when Antinous drowned in the Nile, and his death—whether an accident, sacrifice, or suicide—had a lasting impact on Hadrian, and on art.

No records of the time tell us exactly what happened to Antinous, but Hadrian encouraged his subjects to worship the dead youth as a god and founded a new Egyptian city, Antinoopolis (shortened as Antinoe), in his name. Classical busts and statues portrayed Antinous with a distinctive head of curls, full lips, and athletic body. Some likened him to Apollo or especially Dionysos, the Greek god associated with wine, drunkenness, and the dead. Others looked to Egyptian art in order to link Antinous to Osiris, sometimes seen as a counterpart to Dionysos. Visually and culturally, however, the statues and cults of Antinous followed well-established Greek patterns, reflecting Hadrian's interests as a genteel, highly educated Roman of his day—and a tough, military-trained leader to boot.

One of the statues thought to represent Antinous (Figure 20), now in the Vatican Museum, comes from Hadrian's vast estate at Tivoli, a private refuge from the urban environment of Rome. Complete with palace, gardens, theatres, and temples, the estate created an idealized landscape, with Egypt—and Antinous—built into it. At one end was a pool called the Canopus, after the port near Alexandria where an important temple to Isis stood. The pool led to a temple of Serapis, the god the Ptolemies had invented to supplement Osiris and appeal to Greek and Egyptian audiences

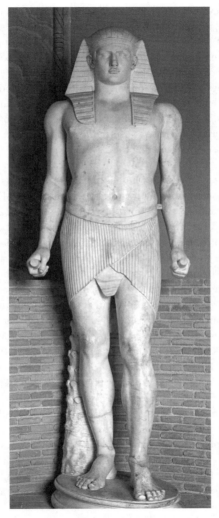

20. Statue of Antinous, from Tivoli, 2nd century AD. Discovered at the private villa of emperor Hadrian, this marble statue probably represents his companion Antinous, said to have drowned in the Nile

alike. Elsewhere in the grounds Hadrian dedicated a temple to Antinous, possibly complete with a tomb. He commissioned a new obelisk of Aswan granite, echoing the obelisk Augustus had brought to Rome for his own temple-tomb some 150 years before. With advice from Egyptian specialists, the obelisk was inscribed with scenes of Antinous offering to Amun, Thoth, and Re. Its hieroglyphic inscriptions praised him as 'Osiris-Antinous'. Archaeologists have suggested that it stood in front of the temple-tomb, with the Vatican statue perhaps inside; palm trees ringed the site, completing the Egyptian scene.

We can't say for certain whether the statue represents Antinous or a generic Egyptian figure used to set the stage for Hadrian's imperial fantasy. Identifying the statue as Antinous relies in part on 18th century restoration of the nose and lips, and a modern preference for seeing it as him. Regardless of its subject, the 2.4-metre high statue must have looked imposing to ancient viewers—an effect its regal Egyptian attire can only have helped emphasize. But to modern viewers, it can look odd because it appears Egyptian yet un-Egyptian at the same time (not unlike the mummy mask we considered above). The figure's bare chest, muscled limbs, and short skirt are broadly comparable to the statue of Kushite king Tanwetamani (Figure 2 in Chapter 1)—but instead of the squared-off, frontal orientation of the earlier work, the Vatican statue tries to make its subject as 'real' as possible, from the tilt of the hips as the legs shift weight, to the sense of muscles stretching against the marble 'skin'. Its Egyptian character derives not from the stone or the style, but from the carefully observed folds and fall of the *nemes* head scarf and the thin pleats and arrangement of the *shendyt* kilt. Even the blunt cylinders the figure cradles in his hands echo the shapes ancient Egyptian sculptors used to model blank space inside a closed fist.

Whether Hadrian really believed his young companion had become a god isn't a question we can answer—but in designing a pleasure garden inspired by the sacred landscape of Egypt,

and including a temple to Antinous, Hadrian acted in keeping with his status as a ruler well placed to marvel at the extent and variety of his empire. Although they seem jarring today, with their Egyptian themes expressed through classical forms, 'Egyptianizing' works like the Vatican statue suited a good purpose at the time. They were also important in shaping European ideas about ancient Egyptian art, because apart from a few obelisks, *shabtis*, and statues, objects actually made in Egypt were rarities in Europe until the late 18th century. When the Vatican statue was uncovered at Tivoli in 1738, it created a stir because it seemed to match other portraits identified with the attractive youth, but emphasized the mysterious Egyptian side of his story. As scholars began to consider the history of ancient art, this Antinous hinted at something in between his more classical-looking portraits, which they greatly admired, and the scant examples of Egyptian art they knew, which looked block-like and ill-formed by comparison.

In the Enlightenment era, Europeans cherished the idea that Egypt was important in the development of Western culture—but how could they hope to understand it when they could not read its hieroglyphs or see its art and architecture for themselves? Thanks to the ambitions of Napoleon, however, that was about to change forever.

The myth of timelessness

When he set out for Egypt in 1798, Napoleon had been contemplating the journey for years. He imagined himself as a new Alexander, a brilliant young leader who would conquer the east. He also had a very practical aim: to find a way of linking the Mediterranean and the Red Sea, creating a shorter sailing route so that France could compete with Britain's successful colonies on the Indian subcontinent. In some ways, Napoleon was ill-prepared for the endeavour. His troops landed in the heat of July, dressed in wool uniforms, with scarce water supplies and

little idea of the resistance they would face. But the specialists (*savants*) he brought with him—engineers, chemists, mineralogists, mathematicians, and artists—persevered in measuring, studying, and recording the country even after Napoleon had left, with an eye to improving its water management and agriculture. One artist, Vivant Denon (later director of the Louvre museum), encouraged the *savants* to focus their attention on the antiquities of Egypt as well, producing detailed drawings of the ancient monuments.

Within three years, combined British and Ottoman efforts had defeated the French troops, who relinquished most of their collection of antiquities to Britain under the terms of the surrender—including the Rosetta Stone, which scholars already realized could be the key to deciphering hieroglyphs. But the *savants* retained their notes, maps, and drawings. Back in France, they began work on the encyclopaedic undertaking that would organize and present their newly acquired knowledge to the world: the *Description of Egypt* (*Description de l'Égypte*), which appeared in twenty text and plate volumes between 1809 and 1829. Engraved using a machine invented for the project, the plate volumes were printed at huge size, with pages opening to more than a metre wide. Together with popular published accounts of the journey, the *Description* opened the European public's eyes to an ancient Egypt they had never before encountered.

Presented in what were considered to be accurate reproductions, many of the recorded monuments spoke to the emerging Romantic idea of the ruin. A plate for the temple of Hathor at Dendera—completed under emperor Tiberius in the early 1st century AD—shows it partly buried under windblown sand (Figure 21). At the time the *savants* made their drawings, they could not read hieroglyphs, and the details of the temple's decoration betray the French artists' own style of execution. They were more at home rendering the architecture itself, from the cavetto cornice and torus moulding that frame the façade, to the lintel of its central doorway, which was intentionally left open as

21. Temple of Dendera, engraving, *Description de l'Égypte* (Vol. 4), 1817. Scholars sent to Egypt with Napoleon's army recorded sites like the temple of Hathor at Dendera, which they published in the mammoth *Description of Egypt*

part of the design (known as a 'broken lintel'). Like the temple of Dendur (see Figure 6 in Chapter 2) from a similar period, the Dendera temple used screen walls in between the columns at its front, closing off the interior of the columned hall while leaving its upper part open to sunlight and air. The columns, which we see repeated four deep in the receding darkness, are unique to Hathor temples. They show the goddess with the face of a woman and the ears of a cow, repeated four times to encircle the column. On top of her head, a small gateway represents a shrine and connects each column to the supports above. This combination of Hathor head and shrine was often used as the handle of a musical rattle called a *sistrum*, whose soothing tones pleased (and placated) goddesses like Hathor and Isis. Many museums have examples of such rattles in bronze or faience.

In antiquity, the Hathor sanctuary was part of a larger complex, and the brick-built ruins on its roof and off to the right are the remains of related walls and buildings. The contrast between the seeming permanence of the stone temple and the decay implied by its setting, amidst drifts of sand and crumbling bricks, reflects European sensibilities of the time. Artists and poets turned away from the modernization of the industrial revolution in search of an untouched past, or so they hoped. But the contrast between the might of ancient cultures and the crumbling of their physical remains also appealed: when the British Museum acquired a colossal sculpture of Ramses II, Percy Bysshe Shelley imagined its ruined remnants in his poem *Ozymandias* as a 'colossal wreck' that spoke to the futility of despotic rulers.

Admired for the supposed timelessness of its pyramids, temples, and mummies, Egypt did double duty as a reminder of how great empires—especially non-Western empires—were doomed to fall. To 19th century Europeans, one way to reconcile the enduring might of ancient Egypt with its eventual disappearance was to blame the impact of Islamic cultures in the intervening centuries. According to this rationale, the modern residents of Egypt cared little about its

ancient past, which only Westerners had the insight and energy to 'discover', as if no one before had noticed the tombs and temples. In the Dendera plate (Figure 21), the figures in non-Western dress chat to each other or gaze away from the temple, while the French soldiers take an active interest, clambering onto the roof or getting to work with their drawing boards. By imagining that the Orient (as it was known) existed in a permanent state of backwardness, colonial powers like France and Britain could justify their efforts to control two Egypts—the modern country for its strategic location and industries, and the ancient culture for its important role in the Bible and as a precursor to Greece and Rome. One enduring response to Egyptian art and architecture was the idea that the ancient Egyptians might not entirely be 'us', but they absolutely couldn't be 'them'.

Changing ideas of Egypt

Throughout the 19th century, the rulers (called *khedives*) who governed Egypt on behalf of the Ottoman empire sought European and American investment to develop the country's infrastructure, including cotton agriculture, banking, railways, and hydraulic projects like the Suez Canal. On the back of these investments came organized tourism and the new discipline of archaeology. In the 1850s, Said Pasha appointed the Louvre curator Auguste Mariette to a government post as inspector of antiquities for Egypt. Mariette created a national archaeological service to license excavations and a museum in Cairo to study and display the finds; foreign archaeologists were allowed to send many of their discoveries to museums back home. Although archaeologists from dozens of European and North American countries worked in Egypt, the French continued to run the archaeological service and national museum, even during the British military occupation from 1882 to 1952.

More people could visit Egypt than ever before, but an even greater number of people could encounter ancient Egyptian art and

architecture—or works inspired by them—without leaving home, thanks to a boom in Egyptian-themed architecture, stories and plays, and the decorative arts. Publications like the *Description of Egypt* gave architects and designers all they needed to develop buildings characterized as Egyptian Revival. Using typical forms like the cavetto cornice, broken lintel, and papyrus column, this architectural style was deemed appropriate for commercial or entertainment premises—like the Egyptian House in Penzance, used as a shop and private museum when it was built in 1835—or for structures emphasizing strength and endurance—such as prisons, cemeteries, or the Clifton Suspension Bridge, designed by Isambard Kingdom Brunel and opened in 1864. At the world's fairs and international exhibitions that were so popular in the late 19th and early 20th centuries, visitors could see full-scale, brightly painted reconstructions of Egyptian temples in a carnival atmosphere. For the 1867 exposition in Paris, Mariette loaned real sculptures from the Cairo museum and, in the guidebook he wrote, assured visitors that the donkeys they could hire to ride—an Orientalizing touch—were genuine examples brought from Egypt for the fair.

Whether people experienced Egyptian art and architecture at a world's fair, through Egyptian Revival buildings, or in the many museums whose collections rapidly filled with archaeological finds, what they thought about ancient Egypt depended on their point of view. To some, Egyptian archaeology helped illuminate events recounted in the Bible; for a long time, the assumption that Ramses II was the pharaoh mentioned in Exodus drew attention to his statues and mummy, discovered in the 1880s. To others, ancient Egypt was a novelty with a hint of the mysterious (how were the pyramids built, for instance) and the exotic or erotic. Egyptian art never fitted comfortably into the accepted canon of Western art. Nonetheless, Egyptian subjects appealed to many successful artists, including those more usually associated with classical settings—such as Lawrence Alma-Tadema, whose *Joseph, Overseer of Pharaoh's Granaries* (1874) has details based on tomb

paintings in the British Museum—or Orientalist fantasies, like Jean-Léon Gérôme, whose *Cleopatra before Caesar* (1866) has an interior indebted to the *Description of Egypt*.

In the 19th century, people also looked to ancient Egyptian art and its derivatives—such as William Wetmore Story's 1858 statue of Cleopatra—to try to define ancient Egypt as either white and European or black and African. Story's *Cleopatra* was famous in its day for showing the queen with African features, although viewers today probably assume that the statue—made of marble, like Antinous—is 'white' in every sense. Practitioners of racial science, which assumed that physical differences between humans equated to different abilities, argued that Egyptian art showed the elite with Caucasian features and servants as African ('Negroid', as it was termed). The study of mummies was used in developing ideas about race as well.

More recently, in the context of post-colonialism and national movements for civil rights, ancient Egypt has become an important site for contesting Eurocentric views of Egypt as a source exclusively for Western civilization, a debate still often structured around questions of race. For an installation called *Re:Claiming Egypt*, first developed for the Cairo Biennale in 1992, American artist Fred Wilson combined replicas of ancient Egyptian artworks with pop culture objects—clothing, books and posters, souvenirs—that identify ancient Egypt as a black culture. *Grey Area* is one of Wilson's *Re:Claiming Egypt* works (Figure 22). The sculpture lines up on a shelf five identical casts of the well-known bust of Nefertiti, the 18th-Dynasty queen of Akhenaten whose image has been an ideal of beauty since German excavators found it at Amarna in 1912. But by painting each bust in shades ranging from pure white through greys to stark black, Wilson confronts viewers with the assumptions we make about skin colour, identity, and heritage. In another version of the work, now in the Brooklyn Museum of Art, the colours shift from biscuit-coloured to chocolate brown, conveying the tonalities like swatches on a make-up chart.

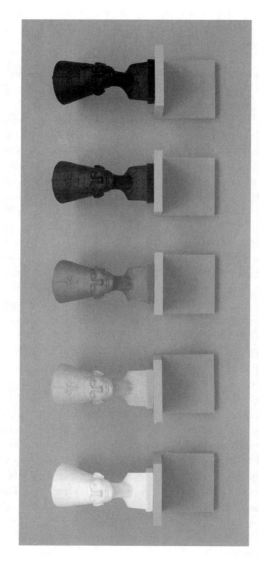

22. Fred Wilson, *Grey Area*, 1993. The American artist Fred Wilson used the bust of queen Nefertiti, painted in hues of white, grey, and black, to address debates about the race of the ancient Egyptians—and the reasons behind the debates in the first place

Ancient Egyptian art and architecture have also contributed to the idea of the modern Egyptian state, which elected its first independent government in 1922—the same year Howard Carter discovered the tomb of Tutankhamun. Part of a cultural movement known as Pharaonism, an Egyptian revival within Egypt saw artists like Mahmoud Mukhtar draw on ancient sculpture and modernist aesthetics to create works that bridged the past and future, most famously his statue *Nahdet Masr* (*Egypt Awakening*, 1928). The Tutankhamun discovery may have sparked fresh 'Egyptomania' in Europe and the US, but it was a source of pride for Egypt, too, which blocked Carter's attempt to share ownership of the finds. Today, the treasures of Tutankhamun are the most visited objects in the Egyptian Antiquities Museum in Cairo, although there are plans to move them to a new museum near the Giza pyramids.

In the 1970s, when Tutankhamun's gold funerary mask (Figure 3 in Chapter 1) and other stunning objects from the tomb toured Europe and the US, it was the first 'blockbuster' exhibition, attracting huge crowds to every host museum. It was also yet another example of ancient art serving a purpose very different from the one it was designed for—in this case, a fresh round of diplomacy between Egypt and the West. The tour followed on from the UNESCO-organized rescue of temples like Dendur (Figure 6 in Chapter 2) that had been threatened by the Aswan High Dam but saved by international efforts, against the backdrop of Cold War and Arab–Israeli conflicts. Since then, museum displays about ancient Egypt have continued to increase in popularity, occupying vast floor spaces in major institutions and attracting millions of visitors per year. Tourism to Egypt (at least until the 2011 revolution) and a wealth of information in the media and on the web are other ways in which people encounter Egyptian art and architecture today—though the ideas it conjures up for them may have much older roots.

As we've seen in this chapter, and throughout this book, what makes art such a powerful medium to begin with is the fact that it

means different things to different people, even people living in the same society at the same time. From the sculptor's workshop where the bust of Nefertiti was first chiselled from limestone, to the shelf where Fred Wilson lined up his questioning copies, Egyptian art has moved and inspired its viewers—and baffled, awed, and angered them as well. In recent years, media stories have drawn attention to calls for Germany to return the Nefertiti bust to Egypt: is it Egyptian heritage that 'belongs' in the land where it was made, or world heritage (a debated idea) that 'belongs' in Berlin, where it was sent with the apparent approval of the European-run archaeological service? There is no simple answer, but the Nefertiti bust in all its guises confirms what this book argues. It has never been more important to understand the legacy of ancient Egyptian art and architecture, for it continues to shape contemporary relationships between the West, Africa, and the Arab world.

Chronology

c.4500–3000 BC	Predynastic era *Statue of Min* (Figure 1)
c.3000–2600 BC	Early Dynastic Period, 1st–3rd Dynasties *Ivory label of king Den* (Figure 12)
c.2600–2180 BC	Old Kingdom, 4th–6th Dynasties *Reliefs of Hesy-Re* (Figure 18)
c.2180–2050 BC	First Intermediate Period
c.2050–1650 BC	Middle Kingdom, 11th–13th Dynasties, *Stela of Irtysen* (Figure 8), *figure of a hippopotamus* (Figure 15)
c.1650–1550 BC	Second Intermediate Period
c.1550–1070 BC	New Kingdom, 18th–20th Dynasties *Mask of Tutankhamun* (Figure 3), *papyrus of Ramses III* (Figure 13)
c.1070–712 BC	Third Intermediate Period, 21st–24th Dynasties
712–332 BC	Late Period, 25th–30th Dynasties and Persian occupation *Statue of Tanwetamani* (Figure 2), shabti *of Horudja* (Figure 4)
332–30 BC	Ptolemaic Period, ending with reign of Cleopatra VII
30 BC– AD 395	Roman Period *Temple of Dendur* (Figure 6), *mummy mask* (Figure 19)

AD 395–640s	Byzantine Period
640s–969	Umayyad, Abassid, and Tulunid Caliphates
969–1171	Fatimid dynasty
1171–1250	Ayyubid dynasty, founded by Salah ad-Din (Saladin)
1250–1517	Mamluk rulers
1517	Conquest of Egypt by Ottoman sultan, Selim I
1798–1801	Napoleon's invasion of Egypt *Description of Egypt* (Figure 21)
1805	Muhamed Ali becomes *pasha* (governor) under Ottoman rule
1849	Death of Muhamed Ali, succeeded by his son and grandsons
1858	Said Pasha, son of Muhamed Ali, appoints French scholar Auguste Mariette to oversee the conservation of antiquities and monuments in Egypt
1867	The Ottoman sultan recognizes the title *khedive* (viceroy) for the rulers of Egypt, beginning with Said's successor Ismail
1869	Opening of the Suez Canal, funded by French shareholders
1875	British government purchases *khedive* Ismail Pasha's shares in the Suez Canal, after a financial crisis
1882	British military occupation of Egypt to suppress a revolt led by Egyptian general Urabi Pasha. Establishment of the Egypt Exploration Society, a charity for British-sponsored excavations in Egypt
1914	Britain proclaims Egypt a Sultanate to oppose Ottoman empire in World War I
1919	Egyptian Revolution, led by Saad Zaghlul, presses Britain for Egyptian self-rule
1922	Britain declares Egypt independent but maintains control of foreign affairs; sultan Ahmed Fuad becomes King Fuad I. Discovery of the tomb of Tutankhamun

1952	Free Officers Movement overthrows King Farouk. Egyptian Revolution (also known as the 23 July Revolution) establishes an Egyptian republic and ends the British occupation
1956	General Gamal Abdel Nasser becomes second president of the republic and nationalizes the Suez Canal; after a military confrontation, Britain and France withdraw their forces from Egyptian territory
1970–81	Presidency of Anwar Sadat; treasures of Tutankhamun tour cities in Europe and the US
1981–2011	Presidency of Hosni Mubarak, ends as a result of the 25 January 2011 revolution

References

The sources listed below support some of the discussions in each chapter, especially in relation to specific objects or buildings. Most of these are written for a specialist audience, and you may need access to a good university library in order to locate them. However, many academic books and journals are increasingly available to read online at little or no cost. For general sources on ancient Egyptian art and architecture, including museums and archaeological sites, see the 'Further reading' section, which follows.

All web resources were up to date as of 11 April 2014.

Chapter 1: Four little words

Robert Steven Bianchi, 'Egyptian metal statuary of the Third Intermediate Period (circa 1070–656 BC), from its Egyptian antecedents to its Samian examples', in *Small Bronze Sculpture from the Ancient World*, ed. Marion True and Jerry Podany (J. Paul Getty Museum, 1990), pp. 61–84 (esp. pp. 72–7, for Egyptian bronzes from Samos).

Barry Kemp, Andrew Boyce, and James Harrell, 'The colossi from the early shrine at Coptos in Egypt', *Cambridge Archaeological Journal* 10:2 (2000), pp. 211–42.

Timothy Kendall, 'Fragments lost and found: Two Kushite objects augmented', in *Studies in Honor of William Kelly Simpson*, Vol. 2, ed. Peter Der Manuelian (Museum of Fine Arts, Boston, 1997), pp. 461–76 (esp. pp. 468–73, for the cache of Jebel Barkal statues).

Larry Shiner, *The Invention of Art: A Cultural History* (University of Chicago Press, 2003), esp. the introduction and chapter 1.

Irene Winter, *On Art in the Ancient Near East*, Vol. 1, *First Millennium BC* (Brill, 2010), esp. chapter 5 (for Phoenician ivories from Nimrud).

Chapter 2: Egypt on display

Anonymous, 'Temple of Dendur, The [Egyptian; Dendur, Nubia]' (68.154), in *Heilbrunn Timeline of Art History* (The Metropolitan Museum of Art, October 2006), Permalink <http://www.metmuseum.org/toah/works-of-art/68.154>.

Betsy Bryan, 'The statue program for the mortuary temple of Amenhotep III', in Stephen Quirke (ed.), *The Temple in Ancient Egypt: New Discoveries and Recent Research* (British Museum, 1997), pp. 57–81 (for the original site of the Sekhmet statues).

Henk Milde, 'Shabtis', in Willeke Wendrich (ed.), *UCLA Encyclopedia of Egyptology* (University of California, Los Angeles (UCLA), 2012), Permalink <http://escholarship.org/uc/item/6cx744kk>.

Christina Riggs, 'Ancient Egypt in the museum: Concepts and constructions,' in Alan B. Lloyd (ed.), *A Companion to Ancient Egypt*, Vol. 2 (Wiley-Blackwell, 2010), pp. 1129–53.

Chapter 3: Making Egyptian art and architecture

Rosemarie Drenkhahn, 'Artisans and artists in pharaonic Egypt', in Jack M. Sasson (ed.), *Civilizations of the Ancient Near East*, Vol. I (Hendrickson, 2006; 2nd printing), pp. 331–43.

Chloë N. Duckworth, 'Imitation, artificiality and creation: The colour and perception of the earliest glass in New Kingdom Egypt', *Cambridge Archaeological Journal* 22:3 (2012), pp. 309–27 (for a detailed discussion of the production and value of glass).

Marsha Hill (ed.), *Gifts for the Gods: Images from Ancient Egyptian Temples* (Yale University Press, 2007) (an exhibition catalogue focused on bronze sculpture).

Georges Legrain, 'Au pylône d'Harmhabi à Karnak (Xe Pylône)', *Annales du Service des Antiquités d'Égypte* 14 (1914), pp. 13–44 (original excavation report on the pylon and scribal statues, available open-access on the web).

Jochem Kahl, 'Archaism', in Willeke Wendrich (ed.), *UCLA Encyclopedia of Egyptology* (University of California, Los Angeles

(UCLA), 2010), Permalink <http://escholarship.org/uc/item/3tn7q1pf>.

C. A. Keller, 'How many draughtsmen named Amenhotep? A study of some Deir el-Medina painters', *Journal of the American Research Center in Egypt* 21 (1984), pp. 119–29.

Gay Robins, *Proportion and Style in Ancient Egyptian Art* (University of Texas Press, 1993), esp. the introduction, chapter 8 (on composition), and chapter 10 (on changing proportions and style).

Chapter 4: Art and power

Katja Goebs, *Crowns in Early Egyptian Funerary Literature: Royalty, Rebirth, and Destruction* (Griffith Institute, 2008).

David Wengrow, *The Archaeology of Early Egypt: Social Transformations in North-East Africa, 10,000 to 2650 BC* (Cambridge University Press, 2006), esp. chapters 9 and 10 for images and burials associated with early kings.

Pierre Grandet. *Le Papyrus Harris I (BM 9999)*, 2 vols. (Institut Français d'Archéologie Orientale, 1994). (English translations of the papyrus are available online; although some are out of date, they give a good impression of its contents).

R. B. Parkinson, *The Ramesseum Papyri*, British Museum Online Research Catalogue (2011), <http://www.britishmuseum.org/research/publications/online_research_catalogues/rp/the_ramesseum_papyri.aspx> (for the most recent research on the papyri and associated objects, including links to each object in international museum databases).

Ritner, Robert K. *The Mechanics of Ancient Egyptian Magical Practice* (Oriental Institute of the University of Chicago, 1993).

Chapter 5: Signs, sex, status

Melinda Hartwig (ed.), *The Tomb Chapel of Menna (TT69): The Art, Culture, and Science of an Egyptian Tomb* (American University in Cairo Press, 2013).

Patrick F. Houlihan, *The Animal World of the Pharaohs* (Thames and Hudson, 1996).

Barbara Mendoza, *Bronze Priests of Ancient Egypt from the Middle Kingdom to the Graeco-Roman Period* (Archaeopress, 2008), for the Leiden statue of Isis and similar statuettes dedicated by priests.

James E. Quibell, *Excavations at Saqqara 1911–12: The Tomb of Hesy* (Institut Français d'Archéologie Orientale, 1913). (Available to read online, this is an excavation report with photographs and drawings of the tomb decoration).

Wendy Wood, 'A reconstruction of the reliefs of Hesy-Re', *Journal of the American Research Centre in Egypt* 15 (1978), pp. 9–24.

Chapter 6: Out of Egypt

Doro Globus (ed.), *Fred Wilson: A Critical Reader* (Ridinghouse, 2011).

Anne Godlewska, 'Map, text and image: The mentality of Enlightened conquerors. A new look at the *Description de l'Égypte*', *Transactions of the Institute of British Geographers* new series 20:1 (1995), pp. 5–28.

Zaccaria Mari and Sergio Sgalambro, 'The Antinoeion of Hadrian's Villa: Interpretation and architectural reconstruction', *American Journal of Archaeology* 111:1 (2007), pp. 83–104 (for recent excavations at Tivoli).

Christina Riggs, *The Beautiful Burial in Roman Egypt: Art, Religion, Funerary Identity* (Oxford University Press, 2005), esp. chapter 3 for mummy masks of the period.

Molly Swetnam-Burland, 'Nilotica and the image of Egypt', in *The Oxford Handbook of Roman Egypt*, ed. Christina Riggs (Oxford University Press, 2012), pp. 684–97 (esp. pp. 685–91 for the Palestrina mosaic and the obelisk of Augustus).

Scott Trafton, *Egypt Land: Race and Nineteenth-Century American Egyptomania* (Duke University Press, 2004), esp. chapter 4 for representations of Cleopatra.

Caroline Vout, 'Antinous, archaeology and history', *The Journal of Roman Studies* 95 (2005), pp. 80–96 (for the identification and interpretation of Antinous statues).

Further reading

In the *Very Short Introduction* series, the other volumes devoted to ancient Egypt can help you explore some of the ideas in this book further: Geraldine Pinch, *Egyptian Myth*; Ian Shaw, *Ancient Egypt*; and Penelope Wilson, *Hieroglyphs*. The books, websites, and online resources listed below are more specific to art and architecture; an asterisk (*) marks especially recommended resources.

Books about ancient Egyptian art and architecture

Cyril Aldred, *Egyptian Art* (Thames and Hudson, 1985) is part of the 'World of Art' series: an affordable option, although some information and interpretation are out-of-date.

Dieter Arnold, *The Encyclopedia of Ancient Egyptian Architecture* (Princeton University Press, 2003), has more than 600 entries on all aspects of Egyptian architecture, including individual buildings.

Melinda Hartwig (ed.), *The Blackwell Companion to Ancient Egyptian Art* (Wiley-Blackwell, in press) is a specialist collection of essays, presenting up-to-date research on many aspects of the subject.

*Jaromir Malek, *Egyptian Art* (Phaidon, 1999). Part of the 'Art and Ideas' series, this compact, highly readable survey has an attractive design and full-colour illustrations.

*Gay Robins, *The Art of Ancient Egypt* (Harvard University Press, revised edition, 2008). The best all-around survey of the subject,

presented in chronological order to the end of the Ptolemaic period and with an excellent introductory chapter. By the same author, look out for two short guides called *Egyptian Statues* and *Egyptian Painting and Relief*, both published by Shire Egyptology in the UK.

William Stevenson Smith, *The Art and Architecture of Ancient Egypt* (Yale University Press, revised edition, 1999) is a detailed and comprehensive survey; it draws especially on the archives and collections of the Museum of Fine Arts, Boston, where Stevenson Smith had been a curator.

*John H. Taylor, *Death and the Afterlife in Ancient Egypt* (University of Chicago Press, 2001) draws on the collections of the British Museum to consider mummification, coffins, and tomb equipment throughout Egyptian history.

Richard H. Wilkinson, *Reading Egyptian Art: A Hieroglyphic Guide to Egyptian Painting and Sculpture* (Thames and Hudson, 1994) helps readers identify and understand the use of hieroglyphic symbols as emblems, attributes, or design elements in Egyptian art. The same author has contributed to Thames and Hudson's 'The Complete . . . ' series, such as *The Complete Temples of Ancient Egypt* and *The Complete Gods and Goddesses of Ancient Egypt*, both of which are widely available.

Museum websites

Many museums with significant collections of ancient Egyptian art offer wonderful online features, from easy-to-use image resources or online catalogues, to web-based exhibitions and teaching resources. Although the list below features US and British institutions, don't overlook museums like the Louvre in Paris, the Kunsthistorisches Museum in Vienna, the Egyptian Museum (housed in the Neues Museum) in Berlin, or the Museo Egizio in Turin—all of which have English-language websites too.

*Brooklyn Museum of Art

An 'Open collections' feature (<http://www.brooklynmuseum.org/ opencollection/egyptian>) lets users browse individual objects as well as an exhibition archive stretching back several decades. Register to join the 'Posse' and curate your own collection online.

*British Museum

The website (<www.britishmuseum.org>) lets you explore object highlights, follow themed online tours, or delve into the collections database (under 'Research'). A child-friendly site (<http://www.ancientegypt.co.uk/>) complements the museum's learning resources for schools.

Global Egyptian Museum

This search platform (<http://www.globalegyptianmuseum.org/>) brings together thousands of objects from 16 museums in Europe and Egypt, with a useful glossary as well.

*Metropolitan Museum of Art, New York

See the Heilbrunn Timeline of Art History (<http://www.metmuseum.org/toah/>) and the home page of the Egyptian Art department (<http://www.metmuseum.org/about-the-museum/museum-departments/curatorial-departments/egyptian-art>), with links to the extensive online collections database.

Museum of Fine Arts, Boston

Browse highlights from the Egyptian collection, or visit the Giza Archives for the Museum's records of early 20th century excavations at the pyramids at Giza: <http://www.mfa.org/collections/ancient-world>.

National Museum of Scotland, Edinburgh

An online collection, 'objects in focus', and child-friendly games feature on this museum website; if you can visit in person, download free apps to explore the museum further: <http://www.nms.ac.uk/our_museums/national_museum_of_scotland.aspx>.

*Petrie Museum of Egyptian Archaeology, London

This university museum—named after archaeologist W. M. Flinders Petrie—pioneered digital cataloguing for Egyptian collections and has many helpful learning resources online: <http://www.ucl.ac.uk/museums/petrie>.

Walters Art Museum, Baltimore

An image-rich site (<http://art.thewalters.org/browse/category/ancient-egypt-and-nubia/>), where visitors can register to create and tag their own selection of works.

Online resources

Eternal Egypt

Developed in conjunction with museums in Egypt, this multimedia site covers Egyptian art, architecture, and archaeology from prehistory to the Byzantine and early Islamic eras. Available in English, French, Spanish, Italian, and Arabic, the best point of entry is <http://www.eternalegypt.org/EternalEgyptWebsiteWeb/HomeServlet?ee_website_action_key=action.display.home>.

Description de l'Égypte

Digitized by the Bibliotheca Alexandrina and the Institut d'Égypte, this website lets you browse through all the plates of the *Description of Egypt* produced by the Napoleonic expedition, as well as the text volumes (in French): <http://descegy.bibalex.org/index1.html>. The New York Public Library (<http://digitalcollections.nypl.org/>) also has a digitized *Description*, if you search by the title or a specific plate.

*UCLA Encyclopedia of Egyptology

An ever-expanding resource, this open-access encyclopedia publishes the latest research from leading scholars around the world, on topics from gods and temples to statues and types of stone. Well worth browsing at <http://escholarship.org/uc/nelc>.

*Echoes of Egypt

Designed to coincide with a 2013 exhibition of the same name, held at the Peabody Museum of Natural History, Yale University, this online version considers European encounters with ancient Egypt, especially from the 19th century to the present day: <http://echoesofegypt.peabody.yale.edu/>.

Index

BEAUTY
A Very Short Introduction
Roger Scruton

In this *Very Short Introduction* the renowned philosopher Roger
Scruton explores the concept of beauty, asking what makes an
object - either in art, in nature, or the human form - beautiful,
and examining how we can compare differing judgements of
beauty when it is evident all around us that our tastes vary so
widely. Is there a right judgement to be made about beauty?
Is it right to say there is more beauty in a classical temple than
a concrete office block, more in a Rembrandt than in last year's
Turner Prize winner? Forthright and thought-provoking, and as
accessible as it is intellectually rigorous, this introduction to the
philosophy of beauty draws conclusions that some may find
controversial, but, as Scruton shows, help us to find greater
sense of meaning in the beautiful objects that fill our lives.

A fascinating book, which I heartily recommend.

Brya Wilson, Readers Digest

African History
A Very Short Introduction
John Parker & Richard Rathbone

Essential reading for anyone interested in the African continent and the diversity of human history, this *Very Short Introduction* looks at Africa's past and reflects on the changing ways it has been imagined and represented. Key themes in current thinking about Africa's history are illustrated with a range of fascinating historical examples, drawn from over 5 millennia across this vast continent.

'A very well informed and sharply stated historiography...should be in every historiography student's kitbag. A tour de force...it made me think a great deal.'

Terence Ranger,
The Bulletin of the School of Oriental and African Studies